DARKROOM
DYNAMICS

DARKROOM DYNAMICS

A Guide to Creative Darkroom Techniques

JIM STONE, Editor

FOCAL PRESS
Boston • London

Focal Press is an imprint of Butterworth–Heinemann.

Copyright © 1979 by Butterworth—Heinemann

Cover design: Susan Marsh
Interior design: Katy Homans
Cover photograph: Peter Laytin

Library of Congress Cataloging in Publication Data
Main entry under title:

Darkroom dynamics.

 Reprint. Originally published: Marblehead, Mass. :
Curtin & London, 1979.
 Includes index
 1. Photography—Printing processes. I. Stone, Jim.
TR330.D37 1985 770′.28′3 85–6809
ISBN 0–240–51767–9

Butterworth–Heinemann
313 Washington Street
Newton, MA 02158–1626

15 14 13 12 11

Printed in the United States of America

CONTENTS

INTRODUCTION ix

THE SABATTIER EFFECT 2
John Craig

The Nature of the Sabattier Effect 4
How to Produce a Sabattier Effect 6
The Test Strip Procedure 8
Methods of Control During Exposure 10
Methods of Control in Processing 12
Tone Control With Bleach 14
Bas Relief and Troubleshooting 16

BLACK-AND-WHITE INFRARED FILM 18
Peter Laytin

Using the Film 20
Using Filters 22
Controlling the Film 24
Processing the Film 26
Infrared Flash 28
Using 70mm Infrared Film 30

PHOTOGRAMS 32
Daniel Ranalli

Light Sources 34
Photogram Materials 36
Making the Photogram 38
Abstraction vs. Representationalism 40

SPLIT-TONING 42
Olivia Parker

Split-Toning 44
Controlling the Split 46

POLAROID PEEL-APART FILM 48
Rosamond Wolff Purcell

Instant Photography 50
The Transfer 52
The Rollers 54
Gilding 56

MULTIPLE PRINTING
Greg MacGregor

58

Blending in the Camera — 60
Sandwiching Negatives — 62
Setting up an Enlarger Blend — 64
Printing the Blend — 66
Complex Printing — 68

ENLARGED PHOTOGRAMS
Dick Bartlett

70

The Process — 72
The Materials — 74
Negative Making — 76
Making Negatives Permanent — 78

POLAROID SX-70
Michael Kostiuk

80

Manipulating the Reagent — 82
Altering the Surface — 84
Transparency Making — 86

HAND COLORING
Christopher James

88

The Materials — 90
Making an Enameled Print — 92
Alternative Methods — 94

TONING
Gary Hallman

96

Print Color With Toning — 98
Toner Chart — 100
Preparing Your Prints — 102
Toning Your Prints — 104
Finishing Up — 106

HIGH CONTRAST
J. Seeley

108

How to Make a High-Contrast Print — 110
Making a Film Positive and Negative — 112
Selecting a Working Film Size — 114
Basic Darkroom Controls — 116

Retouching Litho Film 118
Photomontage 120
Photomontage Examples 122
Masking 124
Tone Separation and Tone-Line 128
Screens and Backgrounds 130
Other Applications 132
Combining Techniques 134
Considerations When Photographing 136
Development for Detail 138
Simplicity vs. Detail 140

LIQUID EMULSION 142
Gail Rubini

Liquid Light 144
Preparing the Piece 146
Applying the Emulsion 148
Processing 150
Finishing 152

RETICULATION 154
Michael Teres

What Is Reticulation? 156
Simple Reticulation 158
Radical Reticulation 160
Veiling 162
Differential Reticulation 164

PHOTOMONTAGE 166
Allen Dutton

Setting Up 168
Assembling the Montage 170
Mounting and Copying 172
Gallery 174

COMBINATION COLORING 176
Benno Friedman

Setting Up 178
Coloring the Print 180

DYE TRANSFER 184
Kenda North

Setting Up 186
The Wash-Off Relief Process 188
Dyeing the Matrix 190
Printing the Matrix 192
Formulas 194

ABOUT THE AUTHORS 196

INDEX 199

Introduction

This book is an encouragement to leave the photographic tradition of representation, and to enter a broader area of creative control. The processes presented are not new, but the work reproduced here is fresh and unique. Each chapter, along with its accompanying reproductions, is the work of a practicing artist. These artist/authors have been selected for several reasons. First, each embodies a commitment to, and an understanding of, a specific way of working with photographic materials. Second, each artist has devoted sufficient effort to a way of working that it has merged with that artist's vision. Thus the imagery transcends the novelty of the process. Third, the editor and the majority of the artists represented here are professional educators as well, teaching in university art departments across the country. From that wealth of experience come lucid and thorough explanations.

The processes are also carefully selected. None demands more experience with photography than that of processing and printing black-and-white film. All utilize readily available materials, and require little equipment beyond a basic black-and-white darkroom. Each chapter has been crafted to present a procedure in as pure a form as possible. Many processes, however, overlap others, and virtually all can be combined. Toning and hand coloring, for example, can be applied to prints made by Sabattier, reticulation, or photomontage. Although intentionally excluded, conventional color photographic materials can be substituted for black-and-white in almost every circumstance.

It would be no challenge, following the procedures outlined in this book, for you to produce images which seem novel and innovative. The difficulty, and the real creativity, will come with your attempt to sustain that feeling of accomplishment. By the very nature of the included material, the possibilities are endless. Consider the suggestions in this book as merely starting points. There are no rules, and as Harry Callahan once said, "that's what makes art better than baseball."

Acknowledgments

The production of this book has been a cooperative project of the highest order. I would like to thank each chapter author for an exemplary job and for tireless cooperation. For production assistance, thank you to Karen Campbell, William E. Crawford, Carlota Duarte, Martha Jenks, Jon Holmes, Arno Minkkinen, Ann Parson, Davis Pratt, Belinda Rathbone, Leslie Simitch, and Kris Suderman. For technical assistance, Dennis Purcell for the Polaroid Peel-Apart chapter, and Frank N. McLaughlin of Eastman Kodak and Larry McPherson for the Dye Transfer chapter. The illustration photographs for the Dye Transfer chapter were made by Alden Spilman. The photograph on p. 5 is courtesy of the Fogg Art Museum, Harvard University, Purchase: Robert M. Sedgwick II fund. The reproductions on pp. 41, 67, and 175 are courtesy of the International Museum of Photography at George Eastman House.

Special thanks go to David Herwaldt for editorial assistance, Katy Homans for a beautiful book design, and to both for moral support. Extra special thanks go to my parents, Charles and Sylvia Stone, for everything.

All set-up illustrations were reproduced directly from Polaroid Land Type 52 black-and-white prints made, unless otherwise noted, by the editor or chapter author.

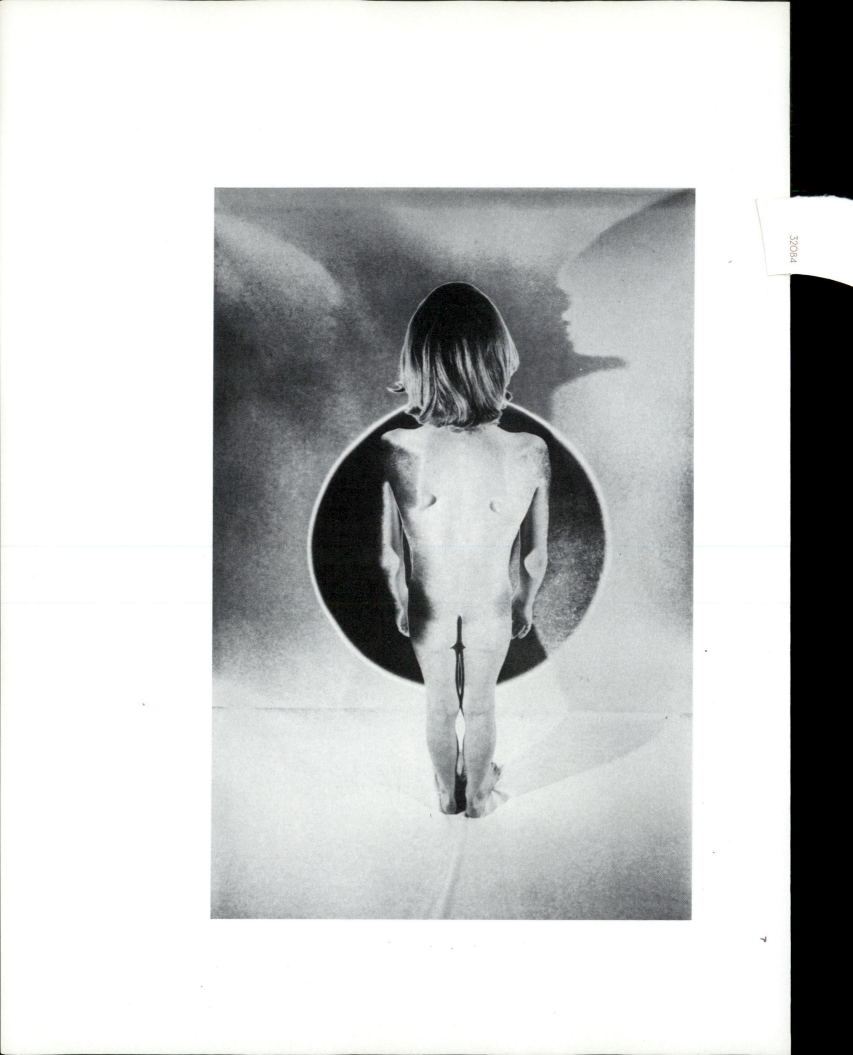

THE SABATTIER EFFECT
John Craig

The French photographer Armand Sabattier discovered in 1862 that unique positive/negative effects could be obtained by reexposing to light and redeveloping an exposed and partially developed negative or print. Ever since then, photographic artists have been intrigued by this phenomenon, commonly though inaccurately called solarization. Many have utilized this effect very successfully in their personal modes of creative photographic expression. An early example is the photographs made from solarized negatives that Man Ray produced in the late 1920s and early 1930s. More recently, such photographic artists as Robert Fichter, Edmund Teske, Jerry Uelsmann, and Todd Walker have creatively used the Sabattier effect in their imagery. Each has dealt with the process in a unique and expressive way that has contributed to the success of his photographic work. I have been fortunate to have come in contact with the work of these artists, and my own imagery has been influenced accordingly.

The Sabattier effect has become a method by which photographers can introduce some painterly graphic elements into photographic image making. Unique and fascinating spatial juxtapositions are created by the combination of positive and negative tonal information in a single print. Photographically real forms become distorted and abstracted.

One of the more interesting results of the Sabattier effect is the creation of Mackie lines, thin white lines on the print formed between adjacent dark and light tonal areas. They serve to separate these areas and accent the positive/negative qualities of the image. These Mackie lines are similar to expressive hand-drawn lines, though they are drawn with light. When working with the Sabattier effect, I feel more like an alchemist or magician than a technician. Subtle as well as dramatic alterations take place on the surface of the print and contribute to a sense of surrealism and the revelation of a separate reality.

The Nature of the Sabattier Effect

The unique visual qualities of the Sabattier effect are the result of a combination of chemical reactions. A piece of ordinary photographic paper is exposed normally, and at some point during the development process the print is reexposed to light. The dark areas, shadows, of the print are affected little by this reexposure, because most of the silver halides in these areas have already been converted to metallic silver by the first exposure and development. The bright areas, or highlights, still contain unexposed or slightly exposed and undeveloped silver halides, which remain light-sensitive. These can still be converted to metallic silver through additional exposure and further development. The result is a darkening of these highlight areas to a light or very dark gray, depending upon how much they were reexposed and redeveloped.

Two other manifestations of the Sabattier effect are an apparent lightening of the light gray areas of the original print and the formation of Mackie lines. These lines are light, sometimes white, and are formed between the light and dark tonal areas of the print. They are the result of chemical by-products remaining from the first development, which retard further development.

Gaining control over the Sabattier effect will require extensive experimentation on your part. The following is a method of working with this process that has evolved through experimentation and experience. Within this method are available countless variations. You are encouraged to find your own, after exploring the few discussed here.

Man Ray, in this image from 1930, "Femme," has achieved an unusual tonal reversal by using the Sabattier effect on the film, which was then printed normally. ▶

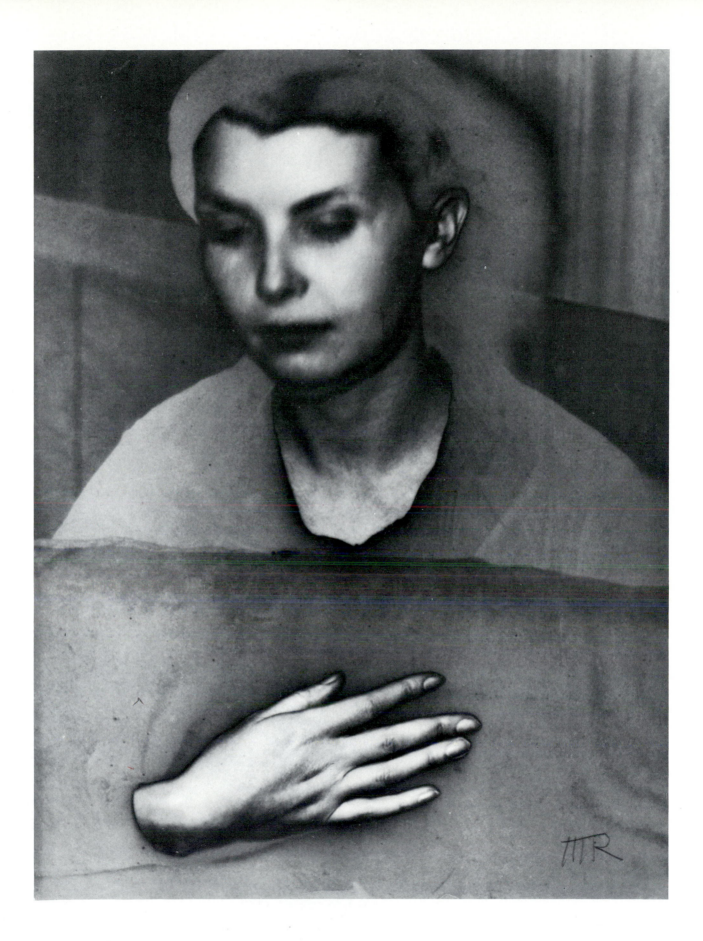

How to Produce a Sabattier Print

Select your negative; virtually any negative will do, although ones with slightly higher contrast usually give more interesting results. Position your negative in the enlarger, decide on the desired degree of enlargement, and focus.

Set up your processing chemicals: print developer, rinse water, print developer diluted 1:10, fixer, fixer remover, final wash water. Do not use stop bath. Turn off the white lights and work under safelight.

Make your first test using a series of exposures with the enlarger of 5, 10, 20, and 40 sec. Develop this strip for 1½ min, rinse, and fix.

Examine the test strip under white light to determine the best printing time. Select a time that gives a slightly lighter than normal print but still maintains a good black shadow and a crisp highlight, with substantial light areas throughout the print. This requirement is one of the reasons that a paper of higher than normal contrast is usually recommended.

Make a test print using the selected exposure time, exposing a full-sized piece of paper, and processing it normally. Examine this test print for overall appearance, and decide if any further alteration of printing time or development is needed. This full-sized test print, although not strictly necessary, is useful for comparison with the prints to follow.

Make five test prints using the decided-upon exposure time, remembering to mark the back of each for later identification. Place them in the developer one at a time, the second following the first after 1 min, and the rest at 30-sec intervals. Remove them all together to a running water rinse after the last test print has received 30 sec of development. Do not fix them yet. You now have a test series developed 30 sec, 1 min, 90 sec, 2 min, and 3 min.

Remove the prints from the rinse, drain them, and lay them face up on a larger piece of glass, Plexiglas, or stainless steel.

This test strip was made on grade 5 paper to determine the initial exposure time. From the bottom, the enlarger exposure times shown are 5, 10, 20, and 40 sec.

Squeegee the prints carefully on this surface, stripping away excess water and making sure not to leave water streaks or spots. These, as illustrated at the end of this chapter, will cause uneven reexposure and redevelopment.

Position the damp prints under a controllable light source — any source of white light that can be regulated by your timer. Use another enlarger, if you have access to one, or remove the negative and its carrier from the one you used for the first exposure and use this enlarger. Be sure to protect the enlarger base from moisture and chemical contamination by using a piece of plastic, a tray, or a clean towel under the print and its support surface. If you are using an enlarger for reexposure, stop down the lens, if possible, one or two stops.

Reexpose all five test prints identically in a test strip sequence of 2, 4, 8, and 16 sec. The prints can be reexposed one at a time if you have insufficient room to line them up all together for exposure. When all five have been reexposed, place them together in the tray of diluted developer.

Redevelop the prints in the tray of diluted developer. Although dilution of 1:10 from working strength is my standard, dilutions of 1:4 to 1:12 or more can be used. Rock the tray gently and carefully watch the prints develop. You can use a 2 min redevelopment time as a standard, but feel free to shorten or lengthen the time for different results. Redevelop all five tests the same, and be sure to note the redevelopment time so you can duplicate the results on your final print.

Rinse, fix, and wash the prints.

Examine them closely under room light and evaluate them as shown in the test examples. The series of different redevelopment times gives you a wide range of results from which to choose.

Decide on a suitable combination of reexposure and redevelopment times. Use your creative judgment to determine how you would like the end product to look.

Repeat the redevelopment and reexposure procedure on a full-sized print, using the decided-upon times.

Complete the process with fixer remover, washing, and drying.

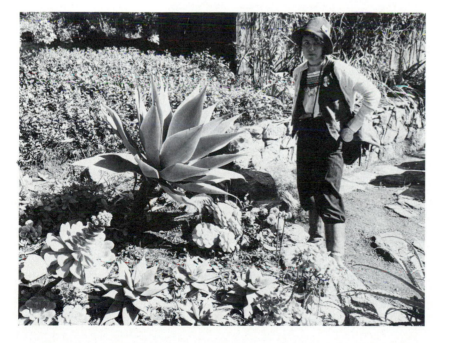

An exposure time of 10 sec was selected from the test strip to yield this test print, which favors the lighter tones without sacrificing a rich black.

The Test Strip Procedure

1. 30 sec development

2. 60 sec development

3. 90 sec development

4. 2 min development

All five of these test strips were given the same initial enlarger exposure: 10 sec at f/11 on grade 5 paper, as in the test print. Developed for the times shown, they were identically reexposed, from the bottom of each, 2, 4, 8, and 16 sec. They were redeveloped together for 1 min.

5. 3 min development

This final print was made after selecting the 8-sec section from the third test strip. The initial exposure time on grade 5 paper was 10 sec, the first development was 90 sec, reexposure was 8 sec, and redevelopment was 1 min. Only by devoting careful attention to detail can you begin to achieve even modestly repeatable results.

Methods of Control during Exposure

These images will show you some of the methods you can use to exert control over how much and where a print is reexposed and redeveloped. Refer back to the original result on the previous page for comparison.

Local Control during First Exposure

The final result can be altered, as in normal printing, by varying the exposure in different areas. In this print the first exposure has been burned and dodged. The corners of the image have been given considerable extra exposure, thus darkening those areas and preventing further alteration from reexposure and redevelopment. The right side of the figure and the plants in the center foreground were dodged for about half of the initial exposure, allowing more alteration to take place during the second exposure and development.

Local Control during Reexposure

Further control can be gained by varying the reexposure. This print was given the standard first exposure but was dodged and burned during the second exposure. The areas around the figure on the right side were given less than the normal reexposure, while the bottom corners were given significantly more, causing variation in the amount of Sabattier effect in different areas of the print.

Selective Reexposure

The standard first exposure was given to this print, but instead of an enlarger as a source of light for the reexposure, a flashlight was used. If you use a flashlight, tape a cone of black paper around the front of your light to allow you to direct the light more accurately; you can also use a small penlight. You can draw with the flashlight and limit the reexposure to selected small areas of the image. The plants in the foreground, the upper left corner, and the area around the figure were reexposed in this way.

Multiple Reexposure

This print began with standard first exposure. For the reexposure the enlarger head was lowered with an empty 35mm negative carrier in position, and just the area in a rectangle around the central large plant was reexposed. The print was redeveloped for 2 min, rinsed, resqueegeed, and repositioned under the enlarger. You can use a red filter in the enlarger to reposition the image without further exposure. Next, the enlarger head was raised slightly, and the print was exposed once more, redeveloped, and completely processed.

Methods of Control in Processing

This is a test print, made on grade 6 paper.

The unmanipulated Sabattier print is shown here for comparison to the prints opposite.

Selective Redevelopment

The print was reexposed normally but not placed in the tray of diluted developer. Instead, the developer was selectively painted on with a small brush, allowing the Sabattier effect to take place only on the top and right side of the image. A very small quantity of developer was used. It is necessary to watch the progress carefully in order to decide when to stop further redevelopment.

Selective Fixing

The print was reexposed overall, but just before its immersion in the redeveloper, a small amount of fixer was carefully applied with a small brush to the diagonal rocks. The application of fixer prevents any further development and consequently prevents the Sabattier effect in the areas on which it is applied. Rinse the fixer from the print with water before redevelopment to avoid contaminating your developer.

Tone Control With Bleach

Frequently, the Sabattier effect will leave you with a print of visual interest that is too dark to be completely satisfactory. Since the overall density of the print is difficult to control while attempting to obtain pleasing Sabattier effect, it is often necessary to lighten the print after processing using a reducer or bleach.

This print is a normal Sabattier print, which received overall reexposure and redevelopment.

Overall Bleaching

This print has been slightly bleached after it was fixed and rinsed. Use commercially packaged Farmer's Reducer, or mix 10g potassium ferricyanide and 5g potassium bromide in 1 liter of water. Both chemicals are available at photo stores. Immerse the print in a tray containing the bleach and watch carefully to avoid overbleaching. This step can be done in room light. Diluted bleach will act more slowly, offering more control. Immerse the print again in fixer after bleaching to clear the yellow stain. Follow with your normal washing procedure.

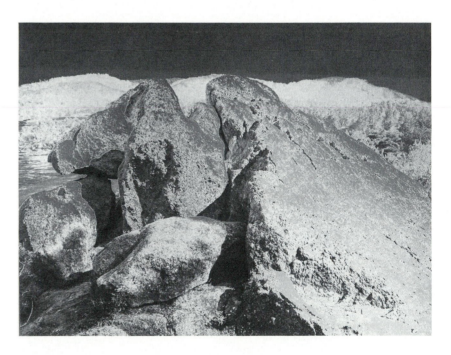

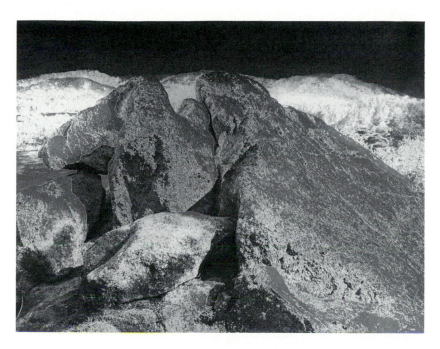

Local Bleaching

By applying the bleach with a small brush or Q-tip, you can limit the reducing action to selected areas. The background and the small rocks in the foreground have been lightened in this manner. You can mix stronger concentrations of bleach if greater or more rapid reduction is desired.

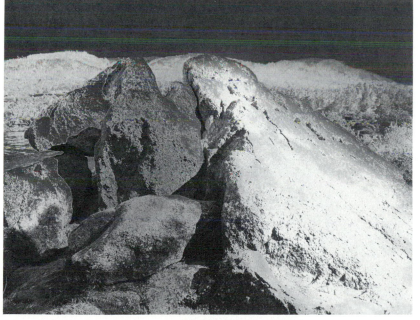

This print was lightly bleached overall in a tray, rinsed, and then brushed with bleach on the large right-hand rock.

Bas Relief and Troubleshooting

Bas Relief

Unusual effects will result from using the enlarger light, with the negative still in place, to reexpose your Sabattier print. The shadow areas, thinner on the negative, receive more reexposure than the highlights. Imprecise alignment of the reexposing image on the print can produce notable edge effects.

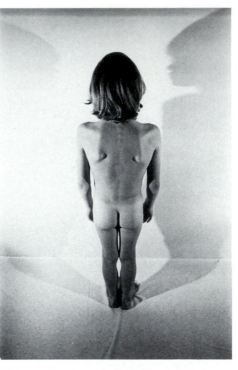

The standard test print, on grade 6 paper.

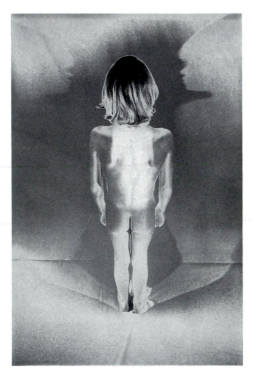

For comparison, a normal Sabattier print, given overall reexposure and redevelopment.

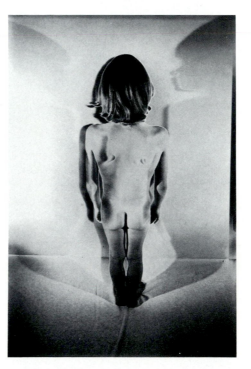

A Bas Relief print from the same negative.

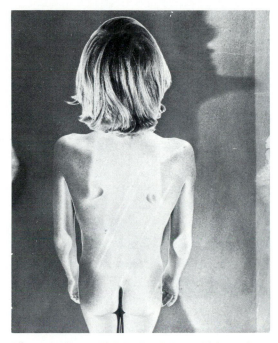

The streaks on this test print could have been caused by uneven or insufficient pressure on the squeegee, or by an uneven or unsharp squeegee blade.

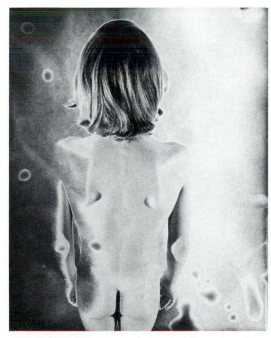

Any water drops remaining on the print during reexposure act as tiny lenses, focusing the reexposure light into marks like these.

Troubleshooting

Most of the unplanned and undesirable marks on your prints will be the result of imperfect squeegee technique. Be sure to use a clean, sharp-bladed rubber squeegee that is longer than the width of your paper. The surface on which you squeegee the print should be flat, smooth, and inflexible.

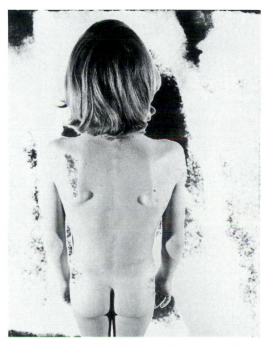

Mottled results like this are frequently the result of overzealous squeegeeing. Too much pressure is as bad as not enough.

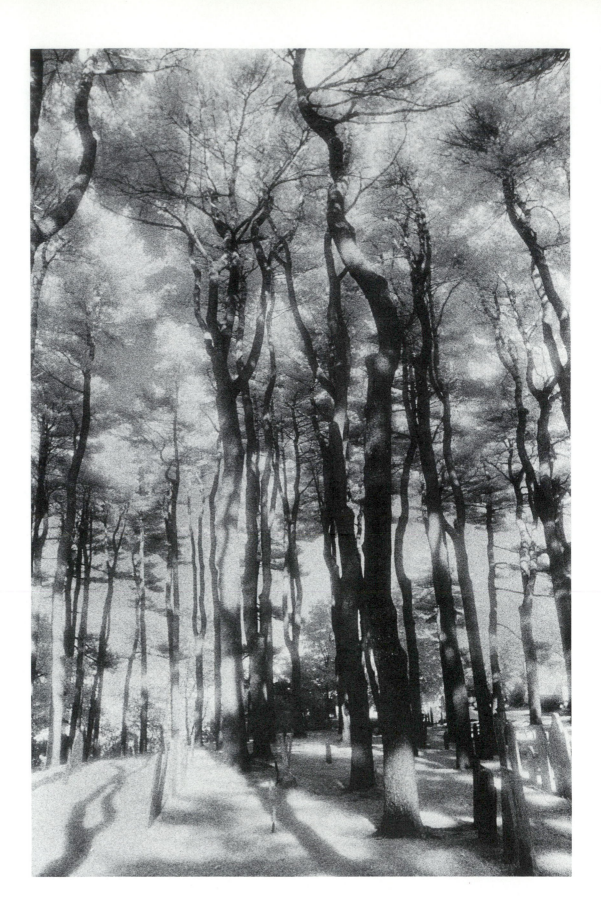

BLACK-AND-WHITE INFRARED FILM
Peter Laytin

The spring-tight line between reality and the photograph has been stretched relentlessly, but it has not been broken. These abstractions of nature have not left the world of appearances; for to do so is to break the camera's strongest point — its authenticity.

Minor White

Like most photographers I began with a 35mm camera. Later, as I became more serious about my work, I began using a 4x5 view camera. After a few years of developing technical proficiency, I felt its constraints and returned to the 35mm camera, beginning at the same time to use infrared film. As different camera formats and films impose their own ways of seeing and working, these choices imposed radical changes on my photographic vision.

Infrared film is sensitive to some visible light, as well as to imperceptible infrared radiation. It is an exciting film with which to work, as it extends vision beyond the normal bounds, rendering objects differently than would panchromatic film and enabling you to see beyond the visible light range. Becoming adept at using infrared film requires a sense for the special tonal relationships produced by the film. Only testing and trial and error will thoroughly acquaint you with the film. While panchromatic film records a scene in tonalities approximating your usual perception, infrared film will record it with a shift in tones. This tonal shift can vary from extremely subtle in one photograph to obvious in the next, depending upon the specific conditions of each. An obvious shift in tones can suggest an unreal, fantasylike state.

Photographs made with panchromatic film suggest realistic tonal and spatial relationships. Having only two dimensions and a frozen, suspended relationship with time, photographs, even if they seem real, are only images and, as such, can only allude to reality. Photographs have their own rules and cannot be dealt with in the same way as the objects they are about. Photographs made with panchromatic film often disguise the difference between the image and the world. Photographs made with infrared film can clarify it.

Using the Film

Black-and-white infrared film is manufactured only by Eastman Kodak. High Speed Infrared Film is available in 16mm for motion picture work, in 35mm cassettes and bulk rolls, and in 4x5 sheets. Infrared Aerographic Film 2424, essentially the same emulsion, is available in 70mm, 5″, and 9½″ rolls. All infrared film is susceptible to fogging from heat and should be kept refrigerated whenever possible.

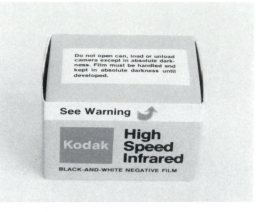

Kodak HIE 135-20 Film; note warning.

Focusing

Because infrared radiation comprises longer wavelengths than conventional cameras were designed for, there is a slight difference between the infrared focus and the visual focus. The glass of the lens refracts the longer wavelengths to a lesser extent than visible light, causing them to come to a focus further from the lens. Most lenses have a red line or red dot marker on the focusing scale to help correct for this shift. After finding sharp visual focus, shift the indicated distance to the red infrared correction mark. It is usually unnecessary to make this shift when using small apertures or when using a wide-angle lens, because of the increased depth of field. When using view cameras, correct by adding 0.25% of the focal length to the lens-film distance.

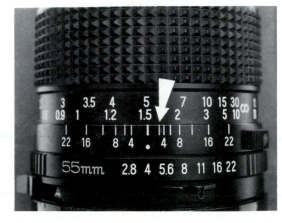

The arrow points to the infrared focusing correction marker, red on most lenses. After focusing visually, in this case to 1.5 meters, the focusing mount should be rotated until the visually focused distance is in line with the correction mark.

To photograph with infrared film, you will need filters, a hand-held meter, and a changing bag, in addition to your camera and film.

Loading the Camera

Infrared film must be loaded into and un-loaded from the camera in complete darkness. The felt strips through which the film leaves the cassette are not opaque to infrared radiation. After loading in the dark, check to see that you have loaded the film correctly by making sure the rewind lever on your camera moves with each film advance. Again, *unload* the camera in total darkness, too.

Load and unload your camera in complete darkness.

The Changing Bag

When using infrared film, you will find a changing bag an important piece of equipment. Since you need to load and unload the camera in total darkness, and 35mm infrared film is available only in twenty-exposure lengths, you will need a portable darkroom if you want to shoot more than one roll of film. A changing bag is necessary whenever a darkroom is not available.

The cloth from which changing bags are made can leak infrared radiation. Test your changing bag before use to be certain it is safe. In the field, shield yourself from direct sun and use the changing bag in as shaded an area as possible. Change film in a darkroom if at all possible.

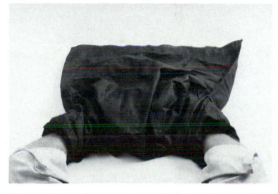

You will need a spacious changing bag to load and unload your camera in the field.

Using Filters

Since infrared film is sensitive to visible light in addition to infrared radiation, filters for the taking lens will allow you to control the relative amounts of each. A No. 87 filter allows only infrared radiation to pass through. Objects will photograph in tones according only to the proportion of infrared radiation they reflect. Objects reflecting the most radiation will appear the lightest, as they do with conventional film. Objects that appear brightest to your eye, however, are not always those that reflect the most infrared radiation, so photographs made on infrared film often have an unnatural or surreal arrangement of tones.

A No. 87 filter passes only infrared radiation. Your eyes are sensitive to nothing passing through the filter, and it appears opaque. If you use a single-lens-reflex camera, the filter must be removed to focus.

A No. 25 filter (red) prevents blue and green light from passing, but transmits red and infrared radiation. Photographs on infrared film made through a No. 25 filter will show more evidence of conventional reflectivity. You can, however, see to focus through it.

Other filters, including No. 58 (green) and No. 12 (yellow), will allow different segments of the visible light spectrum to accompany the infrared radiation in exposing the film.

Without a filter you will be exposing the film with the greatest amount of visible light in proportion to the infrared. Film exposed this way will by no means behave as does panchromatic film, because the film's spectral sensitivity has been extended into the infrared.

Infrared film is also useful for haze penetration, as haze is nearer the opposite, or ultraviolet, end of the spectrum. Best for removing haze is a No. 25 or 87 filter in combination with a polarizer.

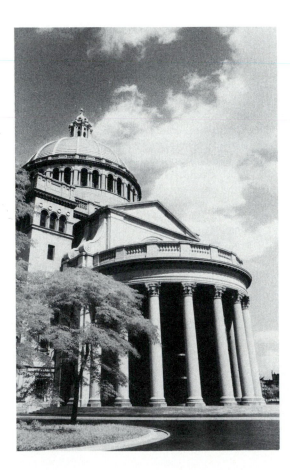

Without a filter over the lens, infrared film will record tones similar to panchromatic film. Foliage will appear lighter than normal and skies darker.

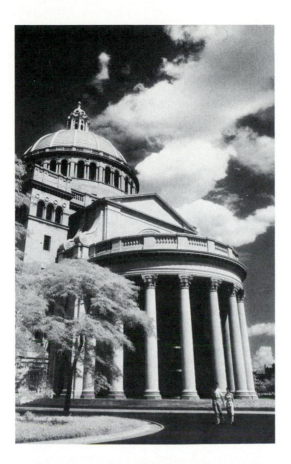

A polarizer, as would a yellow, orange, or green filter, removes the blue part of the visible light spectrum and enhances the infrared effect.

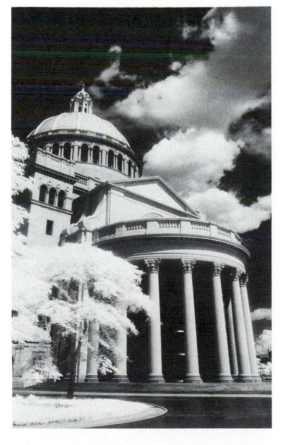

By using a No. 87 filter, which allows no visible light whatsoever to reach the film, you will record only the reflection of infrared radiation. A No. 25 (red) filter will produce similar results.

Controlling the Film

Exposure

Correct exposure for infrared film is difficult to determine. The manufacturer suggests exposing the film through a No. 25 (red) filter and using a hand-held meter at an ASA setting of 50. This has proven to be the best starting point for setting exposures. Use a hand meter rather than one in your camera, because the spectral sensitivity of the meter is affected by the filters over it. There are many different metering systems in cameras today: selenium, CdS, silicon, and so on. Each has a different spectral sensitivity and responds differently to filtration. With the No. 87 filter in place over the lens, through-the-lens metering would be impossible. Use a hand meter at ASA 50 with or without a filter over the lens. I have found, at most, a one-stop difference in proper exposure between the correct exposure with no filter and the correct exposure with any of the mentioned filters, including the opaque No. 87. With panchromatic film there is a three-stop difference between the correct exposures with and without a No. 25 filter. If you have no hand-held meter, you will find it equivalent, but somewhat awkward, to remove the filter each time to meter with one built into the camera.

A normal exposure taken on infrared film with no filter.

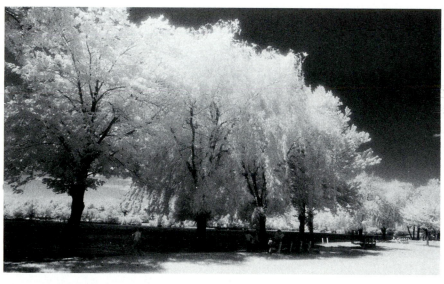

A correct exposure using a No. 25 (red) filter.

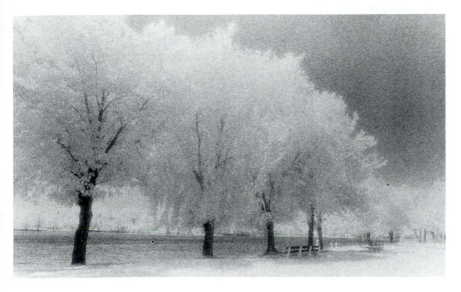

Three stops overexposed using a No. 25 filter.

Static Electricity

Static electricity discharge is more of a problem with infrared film than with most roll films, and the resulting pinholes can be most annoying. To cut down on the friction that causes the static buildup, coat the pressure plate in your camera with a concentrated wetting agent, such as Photo-Flo. Use a high-quality brush or the tip of your finger to coat the pressure plate, and allow it to dry. One coating should reduce your static problems for several months.

Exposure Variations

Exposure variations on infrared film will produce the most significant visual changes in the image, yet exposure is the least predictable variable available to you.

A soft, ethereal, dreamlike image can be obtained by overexposure. A proper exposure will render an average scene with an excellent contrast range. An underexposure of as much as two or three stops will still afford the photographer a relatively good negative, but with blocking in shadows and an overall flatness.

Infrared radiation can vary widely in different locations and conditions, including a variation of as much as three stops between noontime daylight in summer and winter. ASA 50 is a good starting point and will usually produce excellent results, but it is only a recommendation. Because these variations are so unpredictable, and because of the impact of exposure on your final image, you should bracket each image by several stops until you have gained sufficient experience with the materials.

Three stops underexposed using a No. 25 filter.

Processing the Film

Infrared film is more susceptible than most film to damage from abrasion or fingerprints. Handle it carefully during processing.

Presoak the film in water at least 2 min before processing the film in the same manner as normal panchromatic film. The most useful developer is Kodak D-76 stock. Smoother grain will result from using D-76 1:1, contrast will be increased by using Kodak D-19. The process and all other chemicals are standard. All chemicals should be 20° C, including the water presoak and wash.

Process the film in closed stainless steel tanks. The plastic and open tops of some types of processing tanks might leak infrared radiation and cause fogging. Some plastic tops on stainless tanks are safe. Test first: you might be safe with what you have.

Black-and-white infrared film developed in a normal developer, here D-76, will result in a tonal range similar to that of a panchromatic film.

Developed in a graphic-arts developer, Kodak D-19, the film's contrast and graininess are increased considerably, enhancing its unique response.

Jane Tuckerman made this photograph show-
ing delicate use of the highlight halation
characteristic of infrared film.

Infrared Flash

There are several ways of combining infrared film with electronic flash. Simplest is to cover your lens with a No. 25 filter and use the flash in a normal manner. Similar results are achieved by covering the flash tube with a No. 87 gel. This filter will allow only infrared radiation to pass through it; so the emitted flash will be virtually undetectable. You can thus photograph unobtrusively in movie theaters and dimly lit bars. In low-light situations no filter over the lens is necessary. A No. 25 filter should be used otherwise. You can also buy a special infrared flash unit such as the Nocto 400 by Sunpak. This flash unit is designed to emit light at the principal wavelength and peak infrared sensitivity zone of Kodak HIE Film.

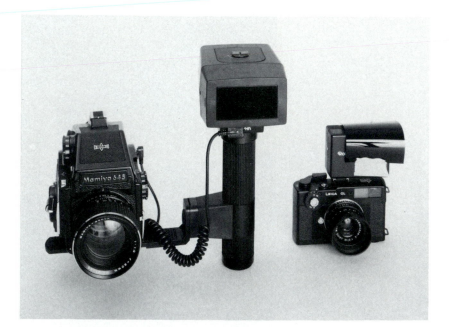

The flash on the left is a powerful unit designed specifically for use with infrared film. On the right is a small standard strobe with a No. 87 filter taped in place over the flash tube. Neither flash emits visible light, and so both can be used unobtrusively.

Tom 1973

Brenda 1976. Luther Smith *made these photographs with flash in very dim light by taping a No. 87 gel filter over his small strobe. The filter blocks all visible light emitted by the strobe.*

Using 70mm Infrared Film

Kodak Infrared Aerographic Film 2424, although manufactured primarily for use in specialized aerial cameras, is not noticeably different from the emulsion available in 35mm. This larger size film can be adapted for use in conventional equipment, although it requires the acquisition of some apparatus of limited usefulness:

1. 70mm film, twice 35mm width, has the same available image area as 120 film, plus perforations.

2. Watson 100 ft 70mm bulk loader will accommodate the supplied 150 ft bulk rolls of film.

3. Kindermann 70mm developing tank and reel holds 2.5 liters of developer and up to 4.6 meters (15 ft) of film.

4. 70mm cassette, unavailable for purchase empty, may be ordered containing panchromatic film and reloaded.

5. 70mm film back, this one for Hasselblad, holds seventy 6×6 cm exposures on 4.6 meters of film. Very few manufacturers make auxiliary 70mm film backs.

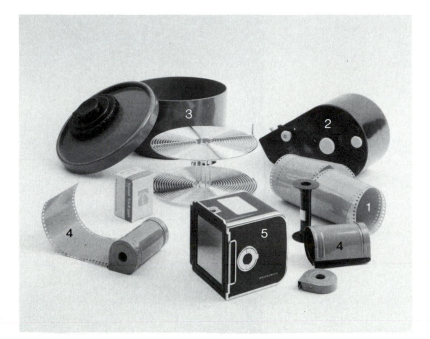

Additional equipment needed to use 70mm infrared film. The 35mm film box on the left has been included to show relative sizes.

*Massachusetts photographer **Neal Rantoul** used 70mm infrared film to make this image. Smoother texture and better tonal separation are two of the benefits of having four times the negative area of 35mm. Neal's experience with 70mm infrared film produced the information on the opposite page.*

PHOTOGRAMS
Daniel Ranalli

A photogram is conceptually quite simple, consisting of the forms recorded by the action of light on sensitized paper without the intervention of camera or lens. Such cameraless images are by no means a recent development in the history of photography, having appeared virtually as soon as an image could be retained by the action of light on silver salts. Ever since the experimentation of William Henry Fox-Talbot, who by 1839 had coined the term *photogenic drawing*, the photogram has provided the means for a wide range of photographic expression, from Man Ray's Dadaist Rayograms, to the work of numerous contemporary artists as diverse as Barbara Morgan, Henry Holmes Smith, and Robert Heinecken.

I think of camerawork as the subtractive domain of photography: the eye, lens, film, and frame act as editorial devices critically eliminating and selecting. Cameraless work embodies the additive domain, the artist illuminating the blank paper with an idea through added increments of light. Thus, the photographer with a camera observes and selects the essential idea by using the rectangular film frame to subtract the extraneous material. The photogram maker starts with a blank sheet of light-sensitive paper and builds a picture by adding ideas, with light, to the empty white rectangle.

There was a time when I considered my objective as a photographer to be the classic standard print with full tonal scale and precise rendition of what I had perceived, selected, and previsualized. Some years ago, however, I experienced a series of events that radically altered my convictions about the importance of accidental and random effects, and the degree to which one might leave an opening for their occurrence and accept their results. Whereas I once felt it necessary to exercise complete control over my process, I now welcome the characteristically unpredictable results when working with the photogram.

Another appealing aspect of the photogram is the high degree of ambiguity possible in the final print. The photogram has all the surface appearances of a photograph, yet the viewer seeking to identify the subject may note that the shadows are reversed, that an object appears translucent, or that there appear to be many subjective meanings. It is this ambiguity, created by the viewer's expectations of a photograph, that offers the artist some of the richest opportunities within the medium.

Finally, I am attracted to working with photograms by the basic purity of the process. While I am by no means opposed to the use of technical apparatus, I often find it gratifying to be engaged so directly with the basic elements of photography — light, paper, and photochemistry — without the encumbrances of cameras, lenses, and accessories, and to have the results manifest themselves so magically.

Light Sources

The procedure for making a photogram is quite simple. Objects are placed atop a sheet of unexposed photographic paper in the darkroom and a light source is directed briefly at the paper. The paper is then processed in the normal manner. The resultant image will appear darkest where it has received the greatest exposure to the light, and white or gray where an object has interceded to block some or all of the light from falling on the paper.

No special equipment is required, although a layout table of some type, with outline marks for the various paper sizes employed and a provision for mounting a lamp at different angles, can be a useful work surface.

Light sources are an important choice, one that should be given serious attention. Certainly one of the most productive exercises for the beginner is to make a series of photograms of the same object using a variety of different light sources so that their characteristics can be seen. I have, at one time or another, used each of the following light sources for exposing photograms, getting with each a somewhat different result:

1. Penlight

2. Flashlight

3. Spotlight bulb

4. Reflector bulb

5. Floodlight bulb

6. 15-watt incandescent bulb

7. Fluorescent tube

8. Slide projector

• Enlarger lamp

These are some of the possible light sources for making photograms.

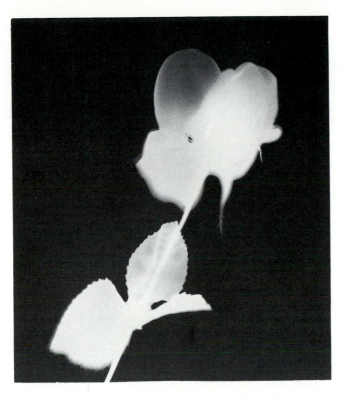

Exposed with a high-intensity desk lamp, almost a point source, this photogram of a flower has clearly defined edges.

The Effects of Light Source Choice

The degree to which the light is focused, or the size of the light source, determines the relative sharpness of the shadow that is cast by objects placed on the paper. For example, the shadow cast by a fluorescent tube is much softer and more diffused than that cast by a reflector bulb. I find a flexible-arm drafting-table-type lamp very useful as a basic lamphouse for exposing photograms. The lower-wattage bulbs will prove helpful in avoiding total exposure of the paper and the consequent overall black tone. They permit a longer exposure and the opportunity for greater manipulation.

For results that have a rich gray scale, the surface of the photographic paper must receive differing amounts of light during exposure. Translucent objects will help in this regard, as will uneven patterns of illumination, which can be obtained by suitable light-source placement. I frequently employ multiple as well as moving light sources, which create more complex, if less controllable, results.

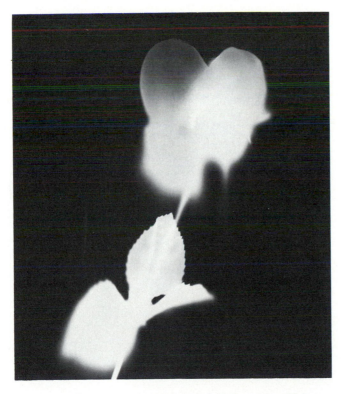

The same flower, printed with a normal incandescent bulb at the same distance, has a softer, more ethereal quality as a result of the broader light source.

Photogram Materials

Equipment necessary is little beyond the most basic darkroom furnishings. Two pieces of equipment prove particularly helpful. The first is a sheet of glass slightly larger than the largest paper to be exposed. Placing it on blocks so that it is raised over the paper to be exposed will permit you to slip photographic paper beneath the glass without disturbing the placement of objects on its surface. You can then lower the glass onto the paper for the exposure.

The second is a red or dark amber gel large enough to fit over the cone of the lamphouse. Black-and-white photographic paper is not sensitive to light from this end of the spectrum, and you can arrange objects directly on the photographic paper under illumination from the filtered light without danger of exposing the paper. If the filter is easily removable, you can make the exposure without having to disrupt either the arrangement of objects or the placement of the light source. If you have a red gel over your exposure light to preview your arrangements, the glass is necessary only if you desire repeated prints from the same objects.

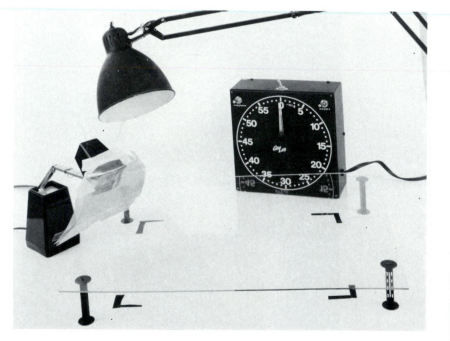

A simple layout table setup consists of an exposing light source with red gel taped in place, a sheet of glass propped up over tape framing marks, and a timer.

Objects for Use

Objects to be used in making photograms are practically unlimited. Virtually anything that can be placed on the paper can be printed. Sharpness depends on the degree of contact between the paper surface and the object as well as the light source employed. Objects of glass, paper, acrylic, and other materials that transmit some light all offer interesting possibilities. I have worked with food, body parts, and clothing with intriguing results. Careful observation of the way light is reflected and refracted by different surfaces and textures is important, just as it is in camera photography.

*Titled **Cheerios, Napkin, and the Real Thing**, this photogram shows the use of recognizable objects to modulate the light.*

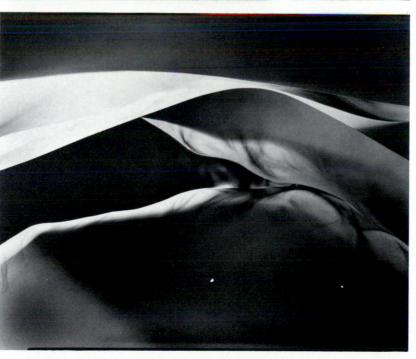

As in the photogram on page 32, the light that formed this image was modulated by pieces of cut cardboard.

Making the Photogram

The Process

Arrange a few objects on a sheet of glass slightly larger than the paper size you are using.

Tape an outline of the paper size, or a piece of plain paper that size, beneath the glass to define the boundaries of your working space.

Move the objects (I use pieces of cardboard) until you have an arrangement that looks promising. Bear in mind that it is necessary to reverse mentally the light and dark values on the paper you see in order to visualize accurately the final printed result. The middle tones, with properly controlled exposure, will print middle gray.

Raise the glass onto spacer blocks. They need only be high enough to allow you to slip the photographic paper under the glass.

Turn off the room light. Work under the safelight appropriate for your paper.

Place your photographic paper in the proper position under the glass.

Lower the glass from the blocks.

Expose the paper. Use an exposure time determined by the simple test on the facing page.

Process the photogram as you would a normal print.

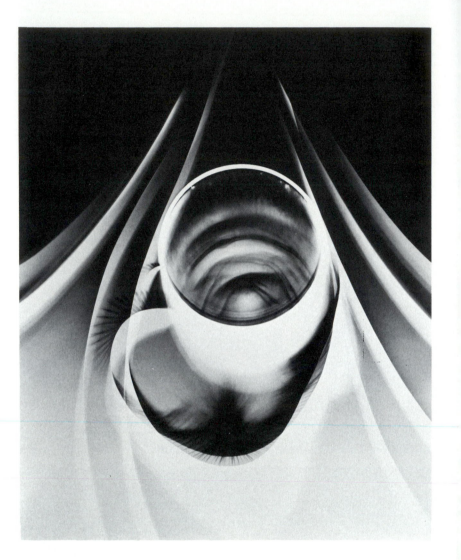

Photogram, 1976

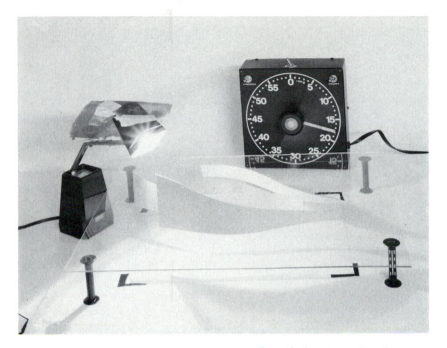

Shapes of cut cardboard placed on the glass cast shadows on the paper below. A photogram made without lowering the glass will have a less sharply focused image.

An Exposure Test

A simple exposure test carried out before making your first print will give you a working exposure range for your light source–paper–developer combination. With your light set at the distance you will be using and plugged into your darkroom timer, make a test strip as you would for an enlargement from a negative. Lay the unexposed test strip under the glass, and cover a few centimeters of the paper at each 5 sec increment. Process the paper in your normal manner. The step when the paper first goes to full black and remains unchanged in the subsequent steps is a good starting point for exposure if you desire full blacks in the final photogram. With a 15-watt bulb 1 meter from the paper, try a range of exposures of from 10 to 30 sec.

It takes me a minimum of three attempts, varying exposure as well as burning and dodging, to achieve a satisfactory result. As many as twenty trials may be necessary to obtain a good photogram. This is no different from the labor involved in obtaining a fine print from a negative. There are few shortcuts to optimum printing, and I have no doubt that my earlier years of careful and arduous printing from negatives have been very helpful in allowing me to achieve the results I seek.

Abstraction vs. Representationalism

Most of my own work with the photogram has been abstract rather than representational. I feel I am using light to make marks on photographic paper, rather than printing the shadows and outlines of objects. My principal interest for some time has been in attempting to make objects rather than images. This is far more than a semantic distinction. One of the most significant differences between a painting and a photograph is that the former is characteristically perceived as a thing in itself, rather than, like the latter, as an image of something else.

Although many photographs abstract from their subject matter, sometimes obscuring identity completely through a close-up or an unfocused or manipulated effect, they usually remain images of things that exist. It has been said that the history of photography is the history of its subject matter, and its subject matter always has been some aspect of reality. Historians and critics of contemporary photography place the photogram out of the mainstream of photography. Indeed, the historian Beaumont Newhall felt it should be seen as a branch of abstract painting. In painting, especially since the late 1940s, the subject matter has often been the very paint itself. I have increasingly sought to make the subject matter of my photograms light itself, and to make objects that have no external reference. My photograms have a subject matter of light capable of entirely arbitrary arrangements. There is no remaining connection with the recorded-reality aspect of the photograph, and they refer more to internal rather than to external associations.

Though my own work is abstract, the photogram offers possibilities for representational imagery as well. The work of Man Ray, especially his photograms that include recognizable objects, is an excellent example of imagery that fully exploits the unique properties of this medium. There is an undeniable ghostlike quality, a kind of dematerialization, that reveals itself in the photograms of many objects. This property should be considered when selecting material for your work.

You may wish to combine your photograms with some of the other approaches to image making offered in this book. Works in color and with nonsilver processes offer rich possibilities as well.

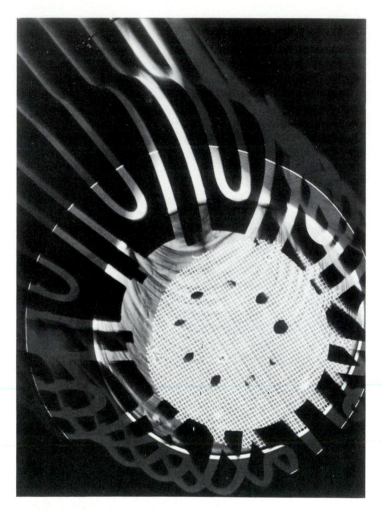

Moholy-Nagy *in this 1922 photogram evidences his use of found objects as light modulators. Moholy's photograms, widely published, have influenced contemporary photographic composition as his writing has influenced today's aesthetic criticism.*

The photogram, or camera-less record of forms produced by light, which embodies the unique nature of the photographic process, is the real key to photography. It allows us to capture the patterned interplay of light on a sheet of paper. . . . The photogram opens up perspectives of a hitherto wholly unknown morphosis governed by optical laws peculiar to itself.

Laszlo Moholy-Nagy

Photogram, 1976. *This color reproduction shows the richness added to the author's work by split toning (see pages 42–47).*

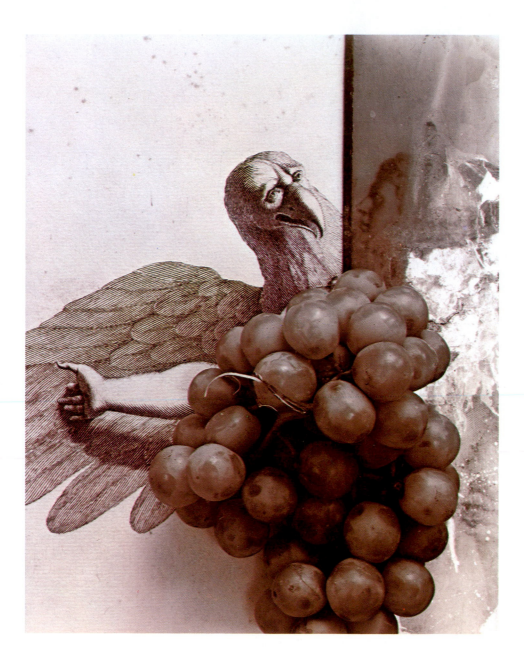

SPLIT-TONING
Olivia Parker

I have been split-toning my silver-chloride prints since 1975. The resulting warm-cool color relationship expands the space within the photograph, lengthens the apparent tonal range, integrates disparate objects, and enlivens the image in a way compatible with my thinking.

Split-toning can be just one more gimmick unless it is used as an integral part of individual expression. I had been a painter before beginning to photograph, and loved to work with color. Yet color photography did not appeal to me because I could not control the image the way I wanted to, and permanence is a problem with color materials. I was fascinated by the special qualities and limitations of black-and-white photography. When I saw a split-toned experiment in a friend's darkroom I could not resist trying the technique. Fortunately, I began experimenting during a warm spell in September as the developer temperature must be warmer than normal for the color I like. The toned prints reminded me of red and white chalk drawings on gray paper. Here appeared a way to work with a kind of color suited to my imagery. Gradually I began to think in terms of split-toned images as I looked through the ground glass.

Often I use flat objects, such as old books, combining them with other objects or peculiarities of light. The split-toning gives the photograph an expanded space that helps me to transform an object into something other than originally intended. Although the shadow areas in my prints become a very dark brown, the whites seem intensely white, because their coldness next to the browns makes them appear whiter. Expressive contrasting edges are heightened. For me, this contrast intensifies the experience of the print.

For a photograph to work, it must have a certain wholeness. Often I find that split-toning can help me combine disparate objects. I have never found that split-toning could salvage an uninteresting image, but it helps unify, making things look as though they belonged together rather than like objects deliberately juxtaposed. In the image opposite, the grapes seem to belong in the engraving. The engraving becomes more spatial; the grapes slip into that space. We all make certain assumptions about the subject of a photograph being real. Here grapes and engraving are so unified that we are forced to question our assumptions about both. Are the grapes drawn? No, they must be real. The setting must be drawn, but how can something real appear to exist in it? This is a simplified explanation of the kind of tension and impact possible in a split-toned photograph, which would be more difficult to achieve in an untoned photograph and impossible in a painting.

Split-toning lends subtle, often unexpected qualities to each image. A piece of cloth may become extraordinarily sensual; a shadow can seem to liquefy or become three-dimensional. I have made a very personal exploration of this technique. I hope that you will find many other ways to use it expressively.

Split-Toning

The procedure for split-toning is generally the same as for standard archival toning, but the prints stay in the selenium toner longer than they would for intensification and permanence.

The paper you select makes a pronounced difference. Split-toning works best on silver-chloride contact papers, such as Kodak AZO, and less satisfactorily on chlorobromide enlarging papers, such as Agfa Portriga-Rapid. Bromide papers are affected very little by the selenium. It is possible but impractical to enlarge onto chloride papers, because the paper is so slow you will need exposure times of 6 min or more. If you do not have negatives large enough to contact print, you can make enlarged negatives using one of several graphic arts films (try Kodak SO-015). Photograms on AZO are another possibility. Dan Ranalli's photograms, shown in the previous chapter, are made on AZO paper and split-toned in selenium.

The developer I use is Kodak Selectol, diluted 1:1. Different developer formulas will affect the final image color, and only experimentation will allow you to evaluate the possibilities.

The temperature of the print developer is the single most critical factor affecting the success of a split-toned print. Since I find the most satisfactory range of developer temperatures to be between 23° and 25° C, I use a water-jacketed developer tray to maintain a constant temperature. I usually use 25° C developer for AZO grades 2 and 3, but grade 4 sometimes works better at 23° C. Developed below or above these temperatures, a print will, when toned, go brownish all over rather than splitting. With some prints, success and failure can be as little as 0.5° apart, although most will yield satisfactory results developed anywhere between 23° and 25° C.

Materials necessary for successful split-toning are few, but rather specific.

Water seems to be a significant variable. In January and February my prints do not have the extreme split in color they achieve in summer. Upon examining analyses of our town water I found some consistent increases and decreases in chemical content and hardness at different times of the year, but there are so many factors I cannot determine which change in the water suddenly improves things in mid-March. When I use distilled water to mix both developer and toner, the split is comparatively poor. You will have to experiment with your local water.

The processing differs little from the normal. I usually develop prints for 1 min, but a shorter development can soften a print and give more overall warmth. Prolonged development can harden and cool the final effect. AZO paper developed in Selectol less than 40 sec or more than 1½ min can yield a degraded image.

After the stop bath and the first fixing bath, let the prints rest in a tray of water until you are ready to refix and tone several prints at once. Be sure to change the water in the holding tray and circulate prints frequently, or stains will appear during the toning.

Toning directly follows the second fixing bath of 4 min. Transfer the prints directly into a toner-clearing bath made of 70ml selenium toner, 30ml Perma Wash, and 20g Kodalk or sodium metaborate to 1 liter of water. If stains occur at this point, you will have to separate these ingredients into two baths, leaving the prints in the first (30ml Perma Wash and 20g Kodalk in 1 liter of water) for 5 min before transferring them to the second bath (70ml selenium toner in 1 liter of water). Put the prints in one at a time, making sure not to splash any toner back into the fixer. Agitate the prints by repeatedly pulling the bottom one out and replacing it on top of the pile. I do about eight prints at a time and have never been able to manage this repositioning with tongs. Selenium, like mercury, is a cumulative poison and can be adsorbed through the skin. I wear inexpensive vinyl surgical gloves, available at the drug store. Be sure you have good ventilation when toning.

Controlling the Split

As you watch the prints in the toner, you will see a brief period of black intensification; then the whole print will look duller and you will wonder why you are ruining a good print. Then the darks will begin to warm, and after a while you will see the split. This will take 4 min or more, depending upon the exhaustion of your toning solution. When you like the color, transfer the print quickly to a water bath. If you then decide it needs more toning, you can put it back in the toner. Grade 4 paper tones faster than grades 2 and 3. I find it splits better in the lighter tones.

I filled many trash barrels with prints before I became comfortable with the process. I still experiment frequently and throw out many. Fortunately, mistakes are not too expensive. AZO is available in grades 0–5 in single weight, but in double weight only grades 2 and 3 are available. Since I print 8x10 negatives on 11x14 paper and do not want to handle single-weight paper in that size, I have to control the contrast of my 8x10 negatives so that they will print well on grades 2 or 3. This is much easier when making enlarged negatives specifically for the process.

Wash your prints after toning for at least 20 min. For permanence I wash two hours at 24° C, and there is little, if any, loss of tone color.

Dry the prints face down on fiberglass screens after squeegeeing. What little flattening is needed can be done quickly in a dry mount press or overnight between rag boards under a pile of books.

The original image color on this untoned print is very slightly olive-black.

Murray Riss split-toned this photograph, enhancing its sense of spatial ambiguity. The original negative was made on 120 roll film and enlarged to make a full-sized negative for printing on contact-speed *AZO* paper.

Removed from the selenium toner at the proper moment, this print exhibits a distinct split in the color from the steel-gray of the lighter areas to the warm brown of the shadows.

If the print is allowed to remain in the toner too long, the brown color will continue to invade progressively lighter areas until the print is a uniform brown color.

POLAROID PEEL-APART FILM
Rosamond Wolff Purcell

A photograph works for me when it goes beyond creating an effect. I am easily enamored of and equally disillusioned by my efforts. They certainly do not seem to reflect my soul. They consist of external facts in more or less arbitrary arrangements. The kind of reasoning I use when working might be the same a writer of brief impressions might use. Photos occur as vignettes rather than as statements. I have difficulty reentering the spirit of older work. I keep hoping for work of greater clarity, spareness, and subtlety.

When using Polaroid materials, I work from print to print rather than more subliminally with negatives, which cannot be examined as the photographic event proceeds. My eyes and emotions select. The camera and prints tell me how much of an illusion will be possible. Although the images occasionally run ahead of consciously applied intelligence, the process is not mysterious. Each print presents itself as an established fact that I must accept, reject, or modify.

Inexplicable passion for different subjects comes in cycles: eight years ago abandoned cars and graveyards, six years ago peeling billboards, four years ago portraits, last year graveyards. The other day an ancient Buick caught my eye. My more abstract concerns remain constant. For ten years they have been light and shadow, confusion of background-foreground in one plane, and what may be imagined about people. Above all, I like puzzles, rather gentle, low-key riddles up to this point. I am still waiting for great wrenching drama from all my work, but ideas come slowly and often seem quite slight.

Usually I use Polaroid film according to instructions, but because the process is relatively simple and fast, and because I take a shot, examine the results and take my next shot based on what I have just seen, the urge to improvise within the conventional recommendations for the materials does occur to me from time to time.

Whenever I sense that I have painted myself into a corner in terms of ideas, I look to see whether there is anything in the corner of any interest. Sometimes there is. Most often there is nothing but dust. Eventually, the paint will dry.

Instant Photography

The Polaroid sheet and pack film processes differ in three basic ways from conventional photography. First, the relatively short time from exposure to finished print enables you to examine the way the film has interpreted your vision and to proceed accordingly. Instant photography implies instant critical participation. Second, the image is conveyed from negative to positive by a migration process called diffusion-transfer. Third, the development of the negative, and the transfer of the image to the positive, are brought about by a layer of chemicals that are spread between positive and negative by a pair of rollers.

These three differences — the instantaneous nature, the diffusion-transfer process, and the chemistry and rollers — provide new areas for manipulation and experimentation, unavailable to users of conventional materials.

The Polaroid films mentioned in this chapter are of two sizes. Pack films, 3¼x4¼, fit Polaroid-made cameras other than the SX-70. Sheet films, 4x5, made for professional use, are usable only in a special film holder made by Polaroid to fit 4x5 view cameras of any manufacture. Types 52 and 58 are sheet films, black-and-white and color respectively, and Types 107 and 108 are black-and-white and color pack films. Other emulsions are also available in these formats. Consult your dealer or write directly to the Polaroid Corporation, Cambridge, MA 02139, for further information.

Picture to Picture

Polaroid is a medium that may be commented upon in the pictures themselves. You may have seen a Polaroid picture in which other Polaroid pictures play a part. The subject holds his image, in which he is seen holding his image, in which . . . and so on, down to, and past, a pinpoint. It looks as though all the images came from the same occasion. You see clear evidence of instant materials: the images have been generated in order to produce a final desired image. The instant materials allow the photographer speed and continuity of thought. When you take a Polaroid photograph, you have instant clues for how to proceed. You might have a finished idea, a piece of a puzzle, or a piece of trash. Examine everything. Even trash can pay off.

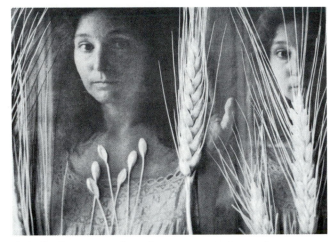

Dried wheat was placed over cut sections of earlier prints to make this assembled piece, rephotographed on Type 52.

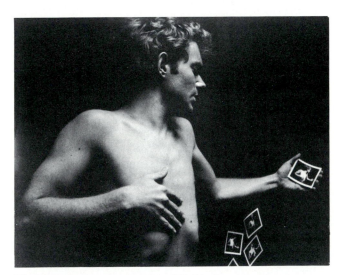

The instantaneous nature of the Polaroid process allows your photographs to contain and comment upon themselves.

Object as Subject

Because the Polaroid process is so rapid, there is an impulse, not economically sound, to feel that the film is expendable. You may feel that something so easy to come by does not have to be treated with reverence. It may take time to have respect for the Polaroid print as an object. Still, if an interesting effect can be made by rephotographing a mutilated image, do not hesitate to mutilate it. You may want to scratch it, draw on it, cut it up. In doing so you may discover something about the medium and its versatility.

Rephotographing Negatives

Rephotographing paper negatives can be a fascinating pursuit. Try rephotographing the muted colors of a Type 58 paper negative again on Type 58. The image fades fast; so any resulting photograph should be made quickly. If the colors are too muted to be rephotographed successfully, gently wipe the negative with a wet cotton swab.

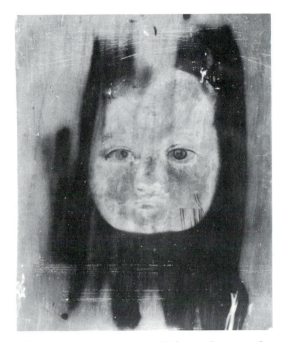

This eerie image was made by rephotographing the negative of the Polacolor print shown on page 55. The dark wash in the center resulted from wetting the negative to bring out the contrast and color. The original of this photograph is in color on Type 58 4x5 film.

Recycling

Recycling of a failed print is shown in the chapter opening illustration. The white streaks on a 3¼x4¼ black-and-white paper negative came from a failed attempt at a photograph. The streaks became a strongly needed element in a new photograph executed on 4x5 Polacolor. This is a still life done under artificial lights and can easily be duplicated. You might come up with a similar situation and want to preserve all elements necessary for re-creating the photo. To the eye, the white streaks faded from white to pink after a few hours, but on film they continue to record as white. It seems best to keep this paper "trash" out of bright light, so that it will not lose its contrast altogether.

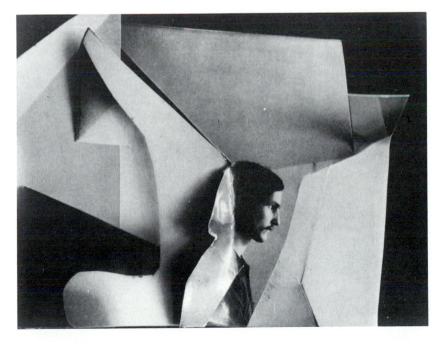

Two Type 107 black-and-white prints were cut into pieces, reassembled, and rephotographed on Type 52 film, making this final image.

The Transfer

The transfer of the developing image to the receptive print material contained within the packet begins simultaneously with the development of the exposed Polaroid negative.

Normally, after the proper processing time, the packet is peeled apart, and the positive and negative separated. The negative is discarded. If, instead, you peel apart a color print, Type 58 or 108, immediately after pulling it through the rollers, you can apply the negative to another surface. If the new surface is chemically receptive and properly porous, the paper negative will continue to transfer its original information onto a new print material. When you again peel the negative, after 60 to 90 sec, the dyes of the image will have transferred onto the fresh surface.

Look for surfaces that are not only receptive to the transferring dyes, but aesthetically pleasing as well. The most receptive surface for the transfer is of course the print material itself. You can apply a negative to another Polacolor print, or you can reapply the negative to the print from which it was removed.

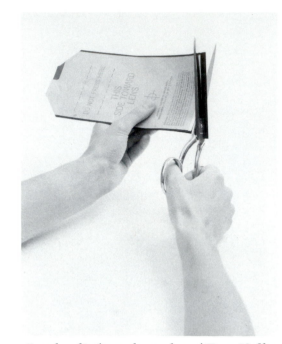

Cut the clip from the packet of Type 58 film immediately after pulling it through the rollers. Peel the negative and apply it to the desired surface.

Reapplying the Negative to Its Image

If you wish to reapply a negative to its own image, wait 15 to 20 sec into the processing time before first peeling, to allow a faint image to establish itself on the positive sheet. Then peel the packet apart and press the negative to the print with a roller or squeegee. The negative and print need not be precisely registered. Uneven pressure from the roller or squeegee will result in areas on the final print unreached by the dyes. This may be just the effect you wish to achieve. Or, when you see it, you may like it more than what you had in mind. After reapplying the negative, develop for at least the indicated normal time, 60 sec. Experimentation with exposure, registration, and development times can produce final prints of unique beauty.

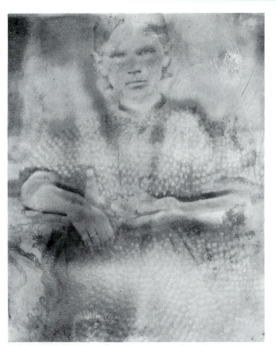

The negative and print from this Type 58 were separated after 20 sec of development, then rejoined out of register. Original in color.

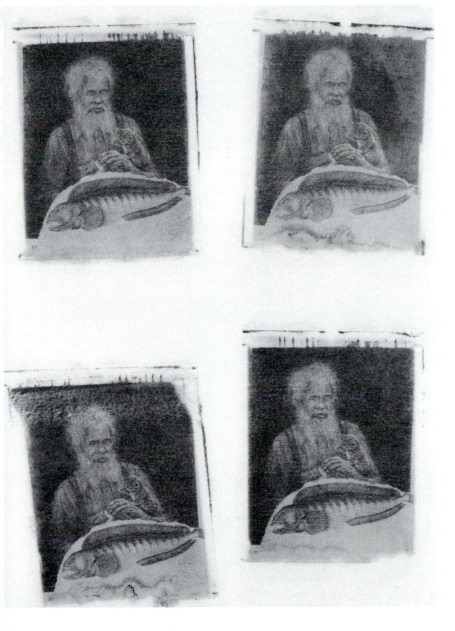

Applying the Negative to Other Surfaces

Other paper surfaces may be more to your liking. I find Japanese rice paper particularly appealing. Cut the clip from the end of the film packet before peeling it apart to apply the negative to paper: the positive sheet with its barely visible image may be discarded or treasured and recycled as a receiving surface for a new negative.

Cut the clip and peel the packet as soon as it comes through the rollers. Press the negative in place with the roller or squeegee without delay. The pressure required to join the two surfaces successfully depends on the receptivity of the new positive. Experimentation will show you how firmly to apply the pressure. If the paper surface pulls apart when the negative is removed, try wetting the next sheet of paper. The activity of the transferring dyes is not inhibited by a damp surface; in fact, depending on the receptivity and dampness of the surface, the dyes may spread and blend in a desirably impressionistic fashion.

The colors on a transferred print will not be as brilliant as they would be on the supplied print material. The hand-done appearance, however, may provide a welcome respite from the sharpness and shine of the print intended for the average consumer.

These four images were transferred one at a time to a larger sheet of rice paper. The original print has a soft textured surface and muted colors.

The Rollers

To develop, clear, and fix a Polaroid print, it must be pulled through a pair of in-camera (or film holder) rollers. The rollers squeeze and break the paper pod that contains all the chemicals necessary to produce a final print 15 to 90 sec later. Before the processing takes place, it is possible to add substances to the negative surface, thereby affecting the appearance of the print.

Expose a sheet of Type 58 or 108 color film (for this purpose, the surface of the black-and-white films seems too sensitive). After the exposure has been made, take the film back or the camera into your darkroom. In total darkness you can open the camera or pull the sheet film packet out with the back in "load" position, thus revealing the surface of the negative.

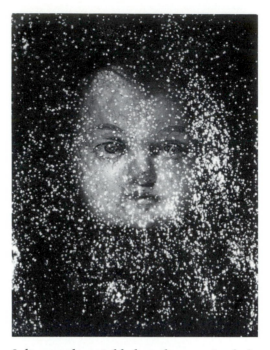

Salt crystals sprinkled on the negative before processing left their mark but needed to be washed off the surface. Original in color.

Interpose any material thin enough to allow the rollers to function. A thin sheet of lens-cleaning tissue or the thinnest of rice papers can be laid on the negative surface. Close the camera or push the packet back into the holder, and process the film. A fine pattern will appear on the final print wherever the photo paper or rice paper has been.

Some materials will affect the development chemically. Try salt, oil, baking powder, Vaseline, toothpaste, or whatever comes to mind. The substance must lie flat on the negative to allow you to reinsert the paper envelope and pull the packet through the rollers.

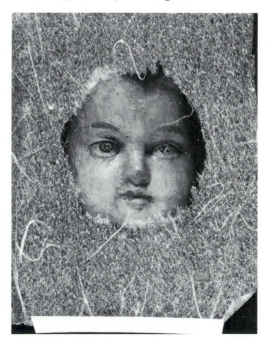

Before the film packet was pulled through the rollers, a hole was cut in a sheet of thin film-cleaning tissue and the tissue placed on the negative. Original in color.

Scratch a negative, again in total darkness, with a sharp mat knife. The negative material is very tough. Firm scratching will result in colored lines on your final print. With some pressure, you will reach the cyan layer of dye; with more pressure, the yellow; with more yet, the magenta.

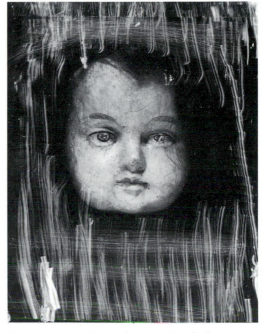

Scratches made on the negative before processing reached the cyan layer. Original in color.

Alter the rollers themselves, taking care not to alter them permanently. Very slim chart tape, used by commercial artists to make graphs, may be wound at intervals along the rollers before the film is processed. It can also be placed directly on the paper packet in any configuration. During these alterations the negative need not be exposed and the lights can stay on. Wherever the tape contacts the packet, development will be impeded, and patterns or shapes will appear in the final print.

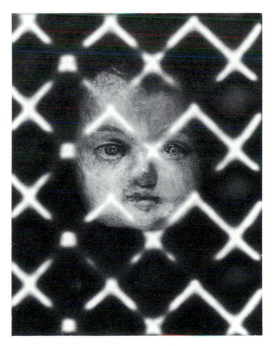

Chart tape placed on the rollers before processing left their imprint on this photograph. Original in color.

Gilding

Gilding is an effect of the chemistry used to develop, clear, and fix the Polaroid print. Because the chemistry is an integral part of the medium, its effects are often visible in the print. Try underexposing by one-half stop and overdeveloping by a minute or more a 4x5 black-and-white Type 52 print. You will probably notice deposits of silver in the darker areas of the print, which have a gilded reversed effect similar to Sabattier (see "The Sabattier Effect," p. 3). Although only occasionally attractive in its own right, this characteristic can be emphasized to good advantage in a new photograph of the original print. The example included here shows a rephotographed Type 52 print in which negative and positive effects are evident in one plane.

Hold one of these gilded black-and-white prints, uncoated, in natural light. You will see that the extra silver reflects and gives back strong impressions of color. If you rephotograph your original gilded print on Polacolor against blue skylight, you will find that the color film picks up even more nuances of color than are visible to your eye. If the natural light is shifting, a second shot of the same print might yield very different colors. The slightest change in light produces different colors from the same black-and-white surface. Color-compensating gel filters can be used to enhance or alter the color change. This is a situation in which Polaroid never-to-be-repeateds are created. The personality of the Type 52, and of other roll and pack black-and-white films, lends itself to a rephotographed Polacolor version. The silver palette has as many photographable hues as are visible to the color film.

Gilding is apparent in this photograph of an overdeveloped Type 52 print. Its edges were folded under, and it was rephotographed on a piece of flowered wallpaper.

MULTIPLE PRINTING
Greg MacGregor

An artist is one who takes the common and ordinary and records it in such a manner that it reads as art. I am continually amazed by the success photographers have with this process, while my search for rules and formulas at work usually fails entirely. My teaching experience, however, has allowed me to draw some conclusions about the process. One in particular stands out clearly: the art-making process often involves defining relationships that replace or contradict the relationships we expect. That is, the artist either perceives new relationships or invents them. Often the artist questions the existing context of an object or event and changes this context in the resulting image.

Photographers usually start this relationship-making process through composition in the camera. They exclude or include certain information so that shapes, objects, and textures are made to appear related to one another. A viewer who scrutinizes the image will perceive the juxtapositions if these visual relationships communicate successfully.

One method I use to create relationships is providing a new context for existing objects and events, thus challenging the believability of an image. The notion that the camera image is not truth is an exciting pivot point in my work. This could be a reaction to my years of accepting without question the camera image as document, evidence, and fact.

I use methods of multiple-printing and collage pioneered in the nineteenth century by O. G. Rejlander and H. P. Robinson and later by Jerry Uelsmann, along with some methods of my own. I use them to present a situation in a photo-real image whose believability is at least questionable, and sometimes preposterous. This neutralizing of old relationships and replacing them with new ones opens the questioning of the credibility of the photographic image.

Blending in the Camera

The simplest way to make a multiple image is in the camera itself. A double exposure is a multiple image, although a simple double exposure can rarely be used to assemble images in a controllable fashion.

By a more complex double exposure technique, you can take a photograph in two halves, each at a different time, and, if desired, each of a different subject. To accomplish this, you must use a camera that has the capability of double exposure. All view cameras, many twin-lens reflex cameras, and a few 35mm cameras will readily allow double exposure. You will also need a filter holder for series filters to fit the taking lens.

Cut a piece of black cardboard into a semicircle to fit into the filter holder. Only the side facing the lens need be black. Assemble the cardboard and the holder as shown in the illustrations on this page to make a blending mask for your camera.

For the first exposure, rotate the filter holder on the lens so that the blending mask protects the bottom half of the film, and make an exposure selecting an image for the top half of the photograph. Use the normal exposure indicated by your meter. Wind the shutter again without advancing the film. Rotate the mask 180° and make the second exposure for the bottom half of the photograph. After this exposure, advance the film to a new frame.

Harry Callahan made this photograph in 1948 by exposing the same negative in his camera thirteen times, moving the camera slightly between exposures. Working intuitively in this fashion, Callahan relied more on chance for his success than you will using the more premeditated assembling of image fragments in the darkroom.

A blending mask can be made by cutting a semicircular piece of black cardboard to fit in a series-type filter holder.

It is important to select an aperture that will allow the two images to overlap each other sufficiently at their intersection to give even density across the negative and eliminate printing difficulties. As a general rule, each image should cross the center line of the negative and fade out completely by about one-third the distance remaining to the protected end of the frame. This can be checked in a single-lens-reflex or view camera by direct observation. If you are using a twin-lens-reflex camera, check by holding a piece of tracing paper in place of the film with the back and taking lens open. The paper acts as a ground-glass screen, and you will see the image inverted through it.

The width of the blended area is less with the increasing depth of field at smaller apertures. The blend line can be moved by cutting a different mask with a larger or smaller section of a circle.

The left-hand blending mask was assembled from a semicircle of black cardboard and a series filter holder. The right-hand camera uses a technical adapter, used to hold gel filters, and a sheet of thin, opaque, black paper.

This surreal image was made by combining two images in the camera, using a blending mask. The joining line is horizontal in the center.

Sandwiching Negatives

You will gain greater control of the process, and have more image-making possibilities, by separating the blending technique into its component stages. Instead of assembling the picture halves in the camera on one negative, you can make the halves separately and assemble them later in the darkroom. In this way you are freed from having to complete each half-idea with the next exposure.

Any camera format can be used to generate negatives for this process, although 35mm film is too small to handle comfortably. In preparation, shoot several rolls of film with the blending mask in place on your lens. Do not double expose. You will be collecting half-pictures. Try to find visual fragments you think will make interesting tops or bottoms of photographs. Remember to rotate the mask 180° to switch from making upper halves to lower halves. Bracket with the aperture to provide different fade-line widths.

After the film is processed and dried, cut it into individual frames, and lay them out on a light table or transparency viewer. Match the blended edges by overlapping various foreground and background negatives until you find a suitable combination.

By adjusting the overlap area you can move the negatives until the density in the intersection matches that of the rest of the negatives. Tape the negatives together, and use two sheets of glass as a negative carrier for enlarging into a final print.

This same blending technique can be used to produce a mirror-image combination that is symmetrical about a middle line. Make two identical negatives with the blending mask in the same position on the lens. This process produces two negatives which fade into clear plastic at the same place. Cut the negatives from the roll, invert one, and sandwich them together to print as just described.

Small apertures, by increasing depth of field, will seem to focus the blending mask, leaving a thin narrow overlap section. This exposure was made at f/22.

The blend area in this photograph, taken at f/5.6, is wide enough to ensure a well-camouflaged blend into another image.

These virtually identical negatives were made
at the same time to make a mirror-image
print.

Sandwiched together base to base, the two
negatives are taped together to keep them
from shifting.

Enlarged from the negative sandwich shown
above, this photograph takes on psychological
overtones from the symmetry absent from
either half separately.

Setting up an Enlarger Blend

Like sandwiched negatives, enlarger blends offer the advantage of using separate negatives. In this case, however, there is an added advantage, in that both images in the blended picture can be made from any of your existing negatives. They need not have been specially made, as for sandwich printing.

Enlarger blending involves the same theory of overlapping images described in the section on camera blends, but the blending occurs on the enlarging paper itself instead of on the negative. You will need two complete enlarger systems, two timers, two easels, and two clip-on filter holders of the kind supplied with Kodak Polycontrast Filters.

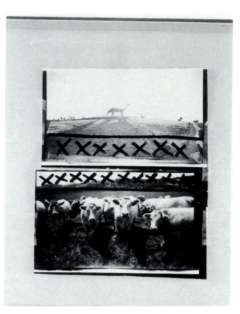

Select two negatives that are to be blended together. Decide where to blend them: any straight line can be used as the blending line.

Mask each lens as you did your camera lens (p. 60) with a piece of black cardboard in the filter holder. Set each lens to the working aperture. The blending mask should cover about half the lens opening, blocking about half the projected image.

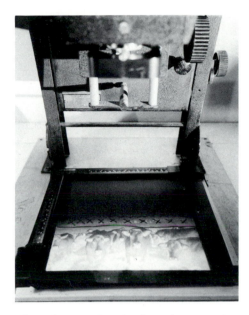

Place the negatives in the enlargers, one in each. Size the images on the easels and focus each.

Adjust the easels to the same size.

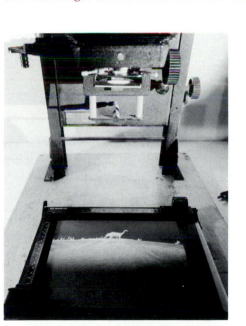

Position each image carefully on the easel so that the overlap area is sufficiently wide and correctly placed. The width of the overlap area can be controlled with the enlarging lens aperture. To facilitate correct positioning, insert a piece of drawing paper the size of your enlarging paper into one easel.

Mark the paper with a pencil to indicate placement of major shapes and the blending line. Transfer the paper to the second easel and position the easel to line up the second image. As before, in the camera blends, there should be some overlap into the other image. You may need to adjust the blending mask to make the blended edge of this image completely overlap the drawn line.

Printing the Blend

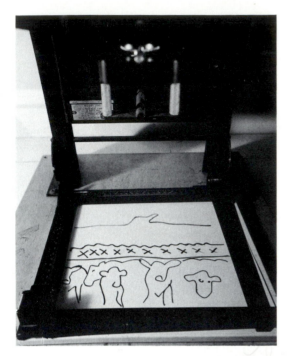

Make test strips for each image after positioning the easels and masks. Select the exposures and filters for contrast. Set the timers and make a test print, exposing one sheet of paper to both negatives, one at a time, before developing it.

Make a final print after making adjustments, based on the test print, to the image and mask positions.

▼

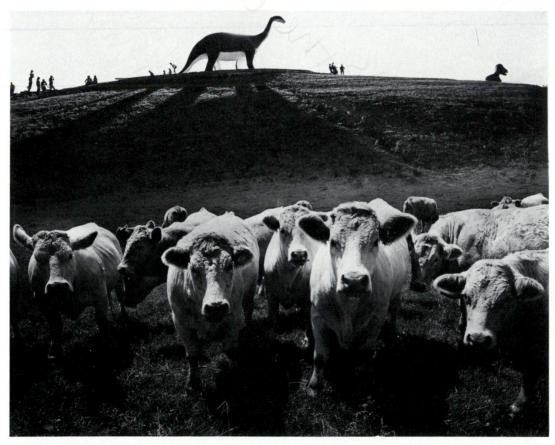

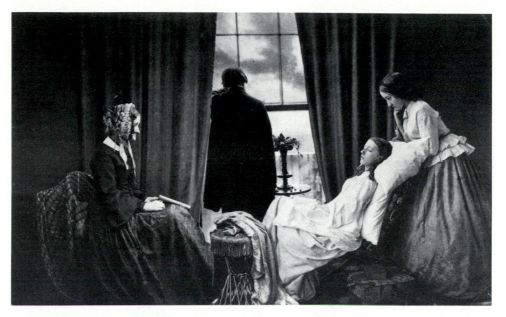

H. P. Robinson, *with the materials available in 1858, was unable to attain sufficient indoor light or depth of field to make this photograph* with a single exposure. The well-known *"Fading Away" was assembled from carefully crafted fragments.*

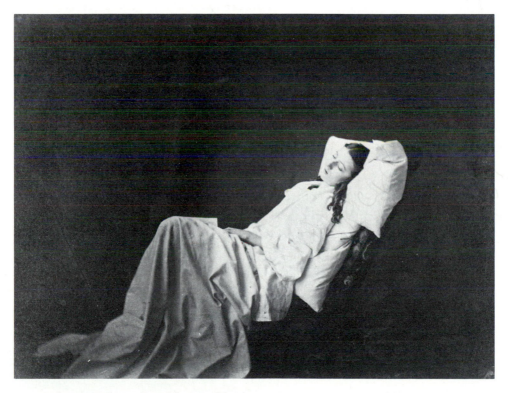

". . . a photograph produced by combination printing must be deeply studied in every particular, so that no departure from the truth of nature shall be detected by the closest scrutiny."

Henry Peach Robinson, 1869

Complex Printing

Blends need not always be made along a straight line. The principles of blending remain the same if complexity is added in the matching of shapes.

In the illustration on p. 58, a hole into which the porpoises were printed was masked out of the image of the swimming pool. To isolate an area like this, suspend a sheet of glass halfway between lens and easel. Make a blending mask in the shape of the area to be blended, again out of black cardboard. Both the height of the glass and the aperture of the enlarging lens vary the width of the blending line. A second sheet of glass for the second enlarger will hold a sheet of cardboard in the opposite shape, to mask a complementary area in the second image. The sheet of glass need not be scratch-free or clean, since imperfections will not be focused on the paper. As before, a piece of paper with the major shapes drawn in with pencil is an essential aid in aligning the images.

Pay attention to the texture surrounding the blends you attempt. Heavily but regularly textured surfaces, such as foliage or rippled water, will allow the best camouflage for a blending edge. Unmodulated gray tones, such as clear sky, are the most troublesome.

The cardboard shape, suspended on glass above the easel, masks out an area into which the second image is printed.

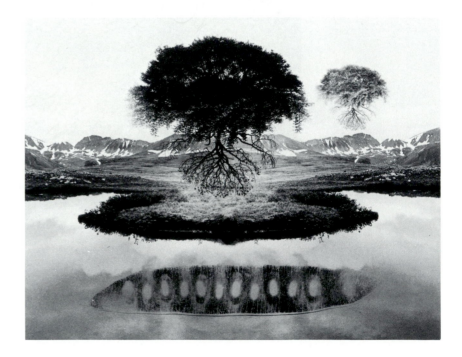

Jerry Uelsmann, *doyen of the manipulated-photo artists, used two identical negatives blended together to make this symmetrical landscape. The floating trees, each made from two negatives, and the peapod were printed in separately with additional enlargers.*

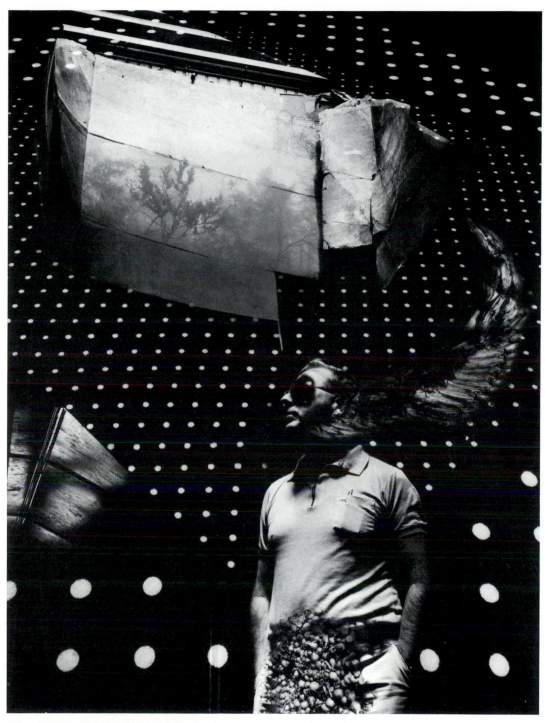

"Bes," 1971. Bart Parker used five enlargers to produce this complex blend from eight different negatives. The upper left corner is a wall lighted by a skylight, on which has been printed a landscape. The dot pattern came from a negative, double exposed in the camera, of a patterned cloth. The figure has been altered by printing in one negative for the eye, two for the wing, and a "rotting beet harvest negative from upstate New York." Parker stresses the importance of using a sheet of paper on which to draw alignment marks, and the necessity of using variable contrast paper.

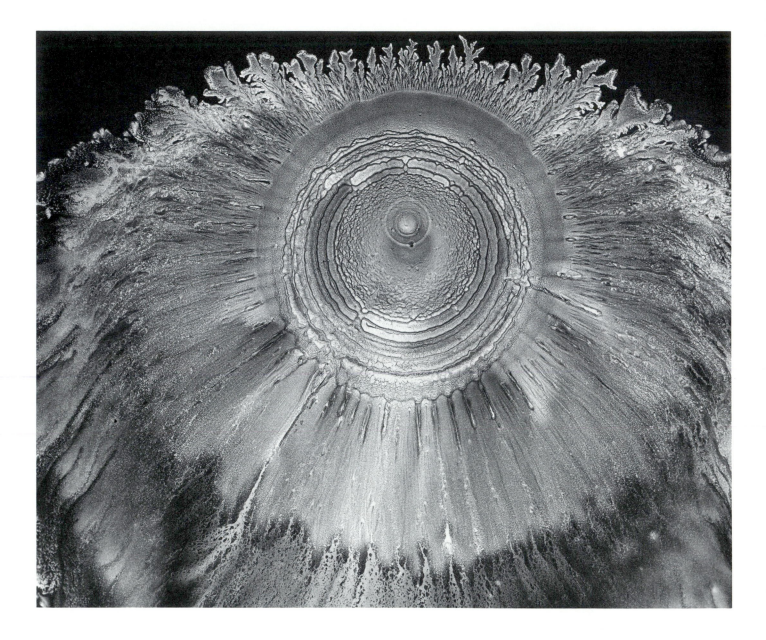

ENLARGED PHOTOGRAMS
Dick Bartlett

My efforts in photography have always been to create the infinitesimal detail and subtle tonalities possible only through photographic processes. At first I imitated the technique of Ansel Adams and worked with large negatives producing contact prints. Aaron Siskind's work introduced me to the possibilities of photographic abstraction. After seeing a show of noncamera photographs by Frederick Sommer, I began work in a technique similar to his, using ink-coated glass sheets as negatives from which to make prints. This freed me from the traditional photographic dependence on the camera and the outside world.

After I became aware of relationships between the forces at work in the processes producing my pictures and similar forces in nature, I found I wanted to combine noncamera and camera-made images. I was aware of the work of Jerry Uelsmann and learned some of his blending techniques. My production of combination pictures has been sporadic because the various elements do not always cooperate.

Since I have found it necessary to earn a living in another field, a common evil, my photographic time is limited. My working habits have evolved from the resulting desire to work with materials found near at hand, in the home. My methods are haphazard, to say the least. I do not standardize but let accidents happen, hoping I am alert enough to capitalize on them.

There are innumerable combinations of materials and methods worthy of investigation. To keep myself from bouncing too rapidly from one to another, I work in stages, completing a prescribed number of prints before moving on. At the present I am fascinated by images produced by the innate properties of the coating substances, so for now I have chosen to keep any painterly hand out of the work. Having begun with an amalgamation of methods of other artists, I feel I have developed something uniquely my own.

The Process

Here is the challenge given us by the early photo-artists: create aesthetically pleasing images on photosensitive paper without the use of a camera. The ways of accomplishing this goal are limited only by your imagination and inventiveness. Most initial attempts meet with failure in each of the areas taught us by conventional photographs: the creation of apparent subject, modulation of tonal values, and the simulation of three dimensions. These three are interrelated, each sliding into the others; and all should be present in a successful image.

The subject in an abstract picture is suggested by a figure-ground relationship. The gradations of tones from black to white help to define the subject and are in themselves aesthetically pleasing. The gradation of tone is also necessary for the creation of a feeling of depth.

As discussed in the chapter on Photograms, the most straightforward approach to noncamera images is to place objects on photographic paper that is exposed to light and then processed. The best objects for this process are translucent, as they modulate the light as well and can be controlled more easily. The next logical step for further control is to make your own translucent objects, which can be printed as negatives. The basic procedure is to coat a transparent base material with a pigmented mixture in a way that allows it to be printed in your enlarger.

The Base Material

Glass is the easiest base material to work with. It is chemical-resistant and remains flat, and most enlargers will accommodate sheets of plain glass in place of the negative carrier. Determine the proper size glass for your enlarger and obtain a dozen or more clean, scratch-free sheets in that size. Most of the materials discussed in this chapter can be easily removed from the glass in the event of an unsatisfactory image; thus, the glass can be reused indefinitely.

Sheets of transparent acrylic plastic (Plexiglas) will make an acceptable base material as well. Although it is less fragile, hence safer, it is much more easily scratched and may interact chemically with some of the materials.

The Pigmented Mixture

The pigmented mixture may be one of a number of solutions. My own negative-producing palette begins with oil-based paints. Alongside are the water-based colors, which will not mix with the oils, and emulsifiers, which can be mixed with either. The others are mostly plastic- or acetone-based. I seldom work with more than two types at any one time.

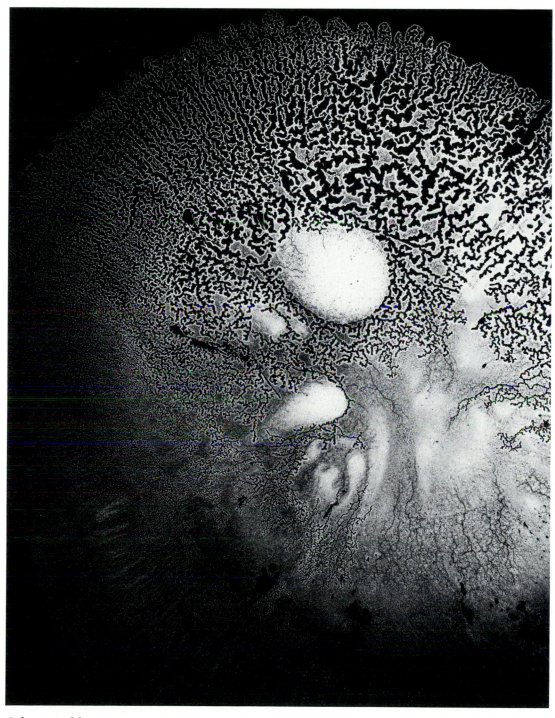

Ink pressed between two glass plates made the negative for this image. The print was made with the ink only partially dry and so cannot be repeated.

The Materials

For negative making, you can use the traditional commercial inks and paints, such as india ink or house paint, or you can use discovered or homemade inks or paints. Discovered paints are such things as toothpaste or shoe polish. Homemade inks are base substances to which you have added a pigment. Fountain pen ink mixed with soap is an example of a homemade mixture, as is pure glycerine combined with watercolor. Henry Holmes Smith made a significant body of work using Karo syrup (see cover illustration). Here is a partial list of some of the more readily available materials:

Commercial Pigments
 Lampblack
 Liquid Opaque
 Acrylic paints
 Felt pen
 Polymer medium
 Poster paint
 Liquid tusche
 Enamel paint
 Carbon paper
 Crayon
 Spray paint

Discovered Pigments
 Mucilage
 Plastic model cement
 Leather dye
 Hand soap
 Clear nail polish
 Tea
 Vaseline
 Hand lotion
 Plastic food wrap
 Cornstarch
 Paper paste

One interesting material is the solution used to coat the backs of fish tanks to give a crystal-like coating. I use a product called Cryst-L-Craze, which, I believe, is acetone-based.

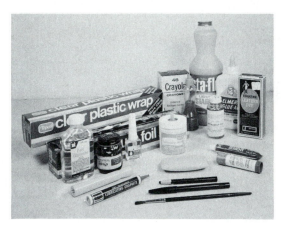

The crystal-like image reproduced here was created with the unlikely combination of soap and plastic wrap. A mixture of water-based poster paint and hand soap was worked together, combining a tone light enough to print with a pleasing amount of froth. This mixture was placed on a glass sheet and covered with plastic wrap. The surface was then pushed around to form a design of wrinkles. When the mixture had dried slightly, not enough to become stuck, the wrap was pulled off and the glass allowed to dry completely. Many more than one such attempt was made before achieving this result.

Negative Making

Coating the base material must be done with care, so that the coating is not too dense to pass light. If a paint is brushed onto a transparent base, the areas painted will be light in the final print, while the unpainted background will be black. The reverse of this procedure is to coat the entire transparent base with the paint and then remove areas you want to be thinner and to print darker. It is better to work with well-thinned paints, as contrast can more easily be added in the printing than removed. An over-contrasty negative is a darkroom disaster, and your first beautiful but unprintable negative will be an important lesson. Compare your photogram negatives to an ordinary camera negative to give yourself an idea of correct contrast. Work for modulated tonal quality and a feeling of depth. It is easy to make an image without a well-defined subject, one that is simply an interesting pattern or texture. To avoid doing so, keep in mind the traditional approach to figure and ground, making one design or specific image the figure and allowing broad textures to become the background.

Compare your photogram negatives to your camera-made negatives to get an idea of proper printing contrast.

Primers and Matrices

Primers and matrices will often help when a pigmented mixture seems to be unusable because it won't adhere to the base material. For example, watercolor will not readily coat sheet plastic. To solve this problem, you can either change the surface or change the material. The surface can be changed by applying a primer coat to give it tooth enough for the material to hold. This can be done with the application of a spray substance made for the purpose, such as Fixatif, available in art supply stores.

To change the material, mix it with a substance that will adhere to the base. A suitable substance, called a matrix, can be any of a number of household items that are both transparent and sticky, such as diluted glue or cornstarch paste. These matrices can be used as primer coats as well, by applying them to the support base.

These negatives were made by applying glue to plastic sheets. After the glue dries to a transparent or translucent state, it is rubbed lightly with pencil lead dust on a rag: the more dust transferred, the higher the printing contrast of the negative. Different glues will produce different crackled or rippled surfaces.

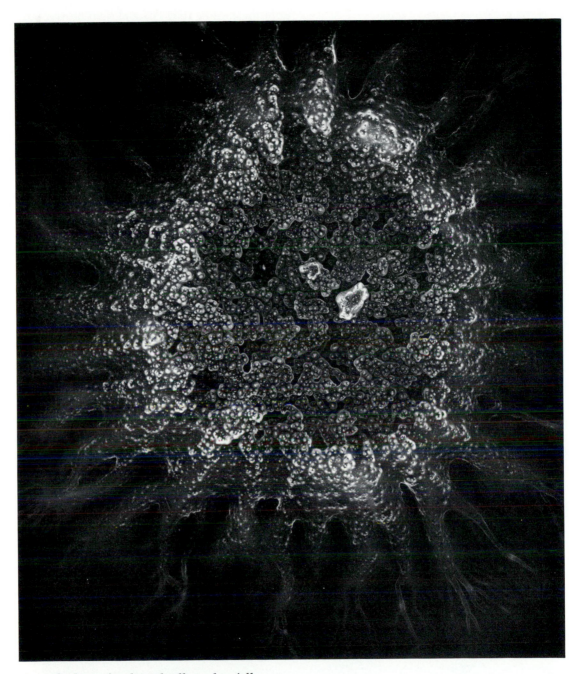

A single drop of india ink allowed to fall on a sheet of glass produced this pattern. The reproduction on page 70 was made the same way. The ink drop making the photogram was quite dirty, which explains the pronounced texture.

Making Negatives Permanent

Many of the negatives made by these techniques, although fragile, are permanent and may be carefully stored for later printing. They should be stored in such a way as to be well separated and supported only by their edges.

Some materials and techniques will yield only a fleeting image. Fugitive images, such as those that are wet and disintegrate on drying, must be printed immediately. If you are interested only in monoprints or small editions,

print these while they last and then move along. Otherwise, you will need to use one of several available means of transferring the image to something from which you can later print.

The most straightforward method is to print directly onto a direct-reversal sheet film, such as Kodak SO-015 Professional Direct Duplicating Film. This film, which can be handled like enlarging paper, will yield a negative you can use to print an image identical to the

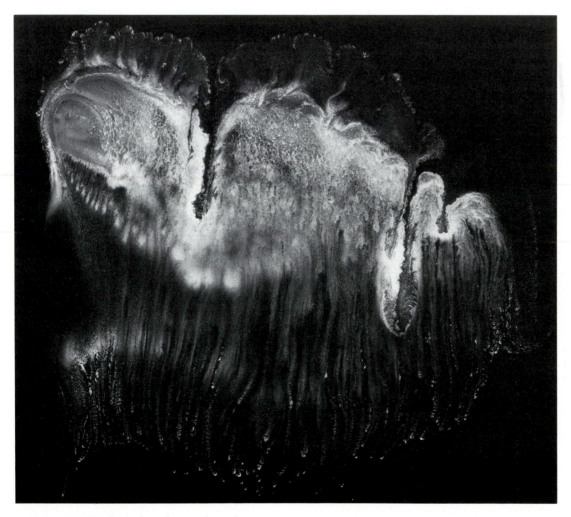

Poster paint thickened with starch and thinned with water was allowed to flow across a tilted glass plate to form this image. Stored properly, the negative is permanent.

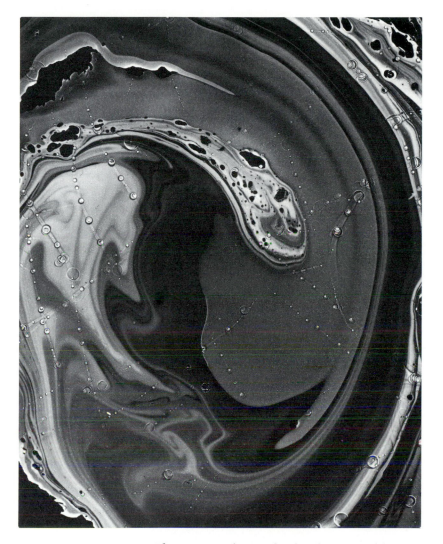

one your photogram negative would have made. Remember to make your enlargements onto film that is either small enough to fit in the negative carrier of your enlarger or large enough to contact print.

Alternately, you can print on either continuous-tone sheet film or single-weight enlarging paper. Either of these, when printed, will make a final print in tones reversed from one made from your original photogram negative. The sheet film can be enlarged, and a print on single-weight paper can be contact printed by squeegeeing it, well washed and wet, face-to-face with a wet sheet of unexposed enlarging paper. Your exposure time will be much longer than a normal contact print.

Further Exploration

Other areas that deserve investigation include translucent bases, such as frosted acetate or papers. Various thin art papers allow for a larger number of direct artistic methods. Drawings can sometimes be transferred to photo-negative materials by contact printing. You can also work directly on photo-negative materials, applying the techniques mentioned here to camera-made negatives. Try discarded or duplicate negatives instead of glass sheets as a support base. Your negatives can be modified and perhaps improved by burning, baking, folding, or tearing.

This print is the result of a classic marbling technique used for centuries by bookbinders. An oil-based paint is floated on a water surface, swirled, and lifted off by gently touching a glass sheet to the surface. The capture of this moving spiral of enamel paint is similar to the capture of a photographic "decisive moment."

POLAROID SX-70
Michael Kostiuk

I began to manipulate photographic prints after I became dissatisfied with the predictability of conventional use of commercially available materials. By reworking the photographic print with various media and tools, I can add to or subtract from the basic offerings of the print itself, giving it new form and life.

Polaroid SX-70 film is a particularly suitable medium for manipulation. This is not to say that the unmanipulated system is insufficient, but as in any photographic process, the camera and film record only a facsimile of that which reflects light. The user is limited to a selection of certain images, and to their physical two-dimensionality. The SX-70 print and the nature of the slow hardening reagent which forms the image allow the user to create by manipulation a new form for the print without time-consuming darkroom reworking.

I acknowledge a preference for certain types of composition, depending on the desired effect and materials available. An attempt to describe how to make art or to formalize aesthetics would be self-defeating. The presentation of discoveries and examples should be a tool and a guide for learning. Initially, many of the images taken for the purpose of manipulation will be unsuccessful. You will be governed by the lighting, the composition, the tools and materials used. Your desire to create new form beyond the traditional camera and film system's offerings will be satisfying if your ideas are reflected through the medium and the medium does not dictate the aesthetics.

Manipulating the Reagent

The easiest, and therefore the most common, method of manipulating a Polaroid SX-70 print is to press on its mylar front surface during development. The colors that make up the image are liquid reagents and harden gradually in a day or two. They are arranged in layers, and before they harden it is possible to rearrange the layers simply by applying sufficient pressure. The pressure alters both the color and the shape, and the resulting image can range from slight surrealism to complete abstraction.

Depending on the effect desired, virtually anything hard, blunt or pointed can be used to manipulate the unhardened, slow-drying reagent of the processed SX-70 print. Avoid instruments that will cut its plastic surface. The only limitation is the tolerance of the reagent and surface to pressure and reworking. Manipulation of processed SX-70 prints can be an additive or subtractive process, not simply rearrangement. Sometimes it is useful to pre-plan an appropriate composition by controlling the desired density, colors, and lighting that will work best for your final manipulated image. Chance and experimentation are part of the learning process. An undesirable print or a mistake in reworking could suggest new alternatives that might otherwise be overlooked.

begin manipulation, the type of instrument, and the amount of pressure you apply. The firmer and smoother the work surface the more delineated the reworking will be. While reworking the print, you are reshaping the image through the plastic protective cover and not actually touching the soft inner reagent that forms the image. Too much manipulation will cause a separation of the plastic protective cover from the positive image, creating air pockets between them.

The type of line or movement you make on the print is your personal, aesthetic decision whether it be hatch marks, circles, figure eights, or just a general pushing around. Experience will tell you how close to an adjoining image area you can work without disturbing it if you wish to leave it untouched.

Surface Manipulation

For the actual manipulation of the print, use a flat, hard work surface such as a table. For work in the field, take along some type of drawing board scaled to fit your needs and working habits. An 8x10 sheet of Plexiglas is light, durable, and easily carried in camera bags or luggage. A small, plastic utility box or shoulder bag for your essential working tools can be helpful when away from the studio. The long hardening time of the print reagent may allow you to manipulate your images when you return to a place suitable for work. Select your tools and working conditions according to your own needs and activities.

A great deal of work manipulating SX-70 prints can be done with hard and soft pencils only. The effect you have on the print will depend on how soon after the exposure you

Rear of Garage 1976

Windows Studio 1976. Manipulation by pressure on the outer areas of these two SX-70 prints creates an unusual spatial isolation of the central subject.

Altering the Surface

Manipulation of SX-70 prints is not restricted to rearranging the unhardened reagent that forms the image. Coloring the surface with felt markers, crayons, ink, or paint is another form of manipulation. The tools and materials needed for manipulating SX-70 prints are the camera, the print film, and such household items as ballpoint pens, pencils, and blunt styluses; these items can be purchased from an office supply, art supply, or drug store.

Not every medium will adhere to the surface of an SX-70 print. The slick top surface may need to be prepared by etching with a dry abrasive or with one of the various sprays or liquid surface preparations sold at most art or drafting supply stores. These treatments are used to give tooth to the plastic top layer so various media will adhere.

The White Border

Manufacturers of prints and print films usually give us white borders around processed prints. If the border interferes visually or aesthetically or does not form a significant aspect of the finished art work, eliminate it. You can do this by constructing a larger window mount of a selected color and size to use over the image. The over-mat can become part of the work by extending the manipulation or drawing onto the white print border or the over-mat, thus freeing the enclosed image area. The large, white lower border of the SX-70 print is available for notes or titles to the works and may constitute a visual element in the final image. Permanent markers or pencils will write on this surface.

The variations in this kind of imagery depend on how you expose the initial image and what you do with it afterwards. Each work is a unique object. Reproductions will not necessarily enhance your work and may be useful only to enlarge the image size. The tactility of the physical alterations to the SX-70 print is frequently more important than large size to manipulated work. An enlargement could allow you to perform extended manipulation in a different scale and to use other media not compatible with the original SX-70 surface.

Self-portrait 2 Nov. 76. This image was effaced solely with a pencil integrating the white surround into the final work as an aesthetic element. Original in color.

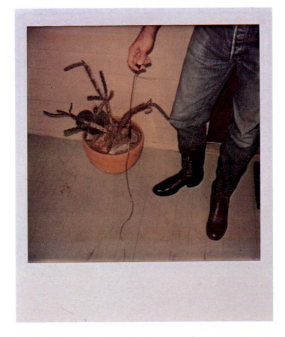

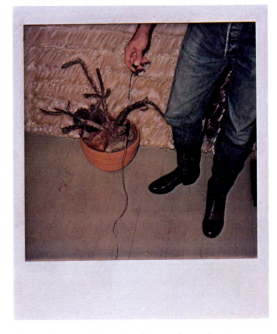

The Texasing of an Artist 1978. This unmanipulated SX-70 print began the evolution of a final altered piece.

The upper portion has been altered using medium pressure from a pencil.

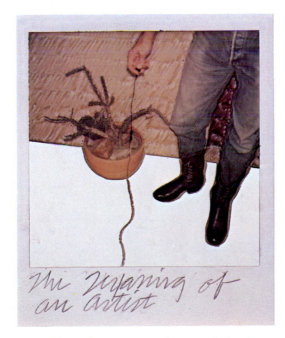

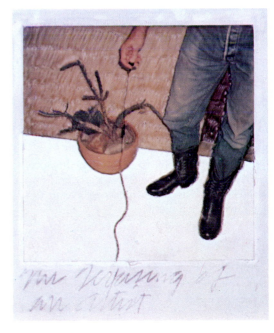

Bristol board was cut to shape and glued to the surface of the print. The title was added with a pencil.

Finally, white crayon was applied to all border and bristol board areas.

Transparency Making

Another possible interesting use of the SX-70 print is to transform it into a transparency.

Expose a sheet of film and allow it to process into a visible image.

Cut away the binding paper — the white border — using a very sharp blade or scissors. The characteristic white surround can be left intact by cutting out the back panel carefully with a razor. Both methods of separation leave the processed image adhering to the transparent front surface.

Rinse the back of the sheet to remove the layer of white processing reagent that remains behind the image. Use warm running water; experiment with various water pressures and temperatures to determine the most satisfactory working method. Be careful not to allow any of the chemicals contained in the packet to remain on your skin. A fragile, transparent image will remain after the wash.

The Effects of Development Time

The most successful transparencies will result from prints that have had several hours in which to complete the processing. The image then will adhere more readily to the mylar front surface and will not immediately loosen and mottle. A very soft, round brush can be used to abrade away the exhausted processing reagent.

If you prefer to transfer the processed image from its plastic support to another surface, begin the steps for the transfer a short time after the image first appears.

Take caution when handling separated print packets, as the manufacturer warns against skin contact with the reagent.

Transferring the Transparency

If the image separates from the clear mylar front surface it will shrivel to almost nothing, but when submerged under running water it will expand and can be transferred to another suitable surface.

This transfer cannot be effected without some physical alteration of the image, and usually adds wrinkles and apparent stretching. Once the remaining transparency is dry, it seems to be relatively stable.

Experiment, again, to determine the suitability of various surfaces for transfer. Porous surfaces, such as mounting board, seem to work well when damp.

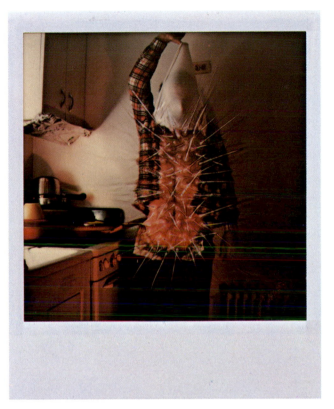

Lucas Samaras, in his *Phototransformation 12/28/73* reshapes the surface of his SX-70 print into a surreal alteration of his own body.

HAND COLORING
Christopher James

A successful photographic illusion will tantalize and tickle reality; I use chromatic manipulation as a feather.

I cannot physically photograph my dreams and fantasies: they reflect no light. I can discover and manipulate realities that are like my dreams, I can invent characters and give them roles to play, but I cannot make the dream itself impress the film with reflected light. However, through color manipulation, my images can approach an interpretation of my dreams.

Unlike many other visual media, photography causes reality to be distorted, interpreted, and perspectively manipulated through mechanical process rather than through an artist's perception. Photographic artists are responsible for the subject, composition, and tonal interpretation of their images, but the image must be recorded while it reflects light, and that is its reality and magic, and, unfortunately, its limitation.

Color perception is a subjective sensitivity, and I prefer my own colors to those I find in reality. Hand coloring and dye manipulation allow me to create beyond the mechanical restrictions of the photographic process and equipment, and to make a selective and individual impact upon the image. In the past, photography has had difficulty achieving art status. The individual photographic artist rarely introduced the art community to anything beyond the verification of a subject's existence and a technical proficiency in translating it to a two-dimensional surface. There are major exceptions, of course. The visual artist creates and offers a gift, something unique; and in photography, the artist causes a subject to become an illusion of itself.

Photography achieves a major portion of its energy through the oscillation between reality and nonreality, the translation of three dimensions to two, and the illusion returning to three dimensions. This effect is often only half achieved. I add color to reinstate the magic of the light and space that initially attracted me to make the image my own. My colors are muted, translucent tints, selectively applied so that the space and accepted reality are altered. A strategically placed value can create the illusion of complete color, and can sometimes imply colors that do not exist on the print's surface. This technique invites the viewer to grow with the work, rather than demanding immediate attention. The divided toning of sepia and chromatic dyes creates a surface that embraces soft values and space. Black-and-white prints with applied color often look like black-and-white prints with color on them. My toned and dyed images, selectively masked and painted, permit the impression of a color photograph without its resolved reality. The translucent enamels, applied after the toning processes, permit the illusion of dimension. Because only selected areas of the print are colored, the nonreality is teased by the reality of what actually exists on the print's surface. This effect involves the viewer, not simply in a subjective evaluation of the perceived image, but in the visual tension of illusion and reality. It is the artist's control of illusion and its individual impact that separates art from photographs. Hand coloring and dyeing are the controls that make the illusion mine.

The Materials

It is pointless to attempt the salvage of an unsuccessful photograph through tonal and color manipulation. All you can achieve by that exercise is the creation of an unsuccessful colored image. Begin with a photograph having resolved tonal grace and harmony of visual elements. You must understand the process of producing a photograph before you begin to alter it.

There are unlimited materials and processes available for you to use in hand coloring. Virtually anything capable of staining can be employed: food and fabric dyes, oil paints, acrylics, enamels, watercolors, marking pens, and your breakfast coffee. The possibilities are limitless.

Begin any hand-coloring process with a completely processed and washed print. With coloring agents such as Marshall's oils, acrylic paints, enamels, oil paints, or marking pens, you will need to dry and flatten your print. Rubber cement, although chemically undesirable, can be applied to the surface of a wet or dry print as a masking device for dyes and staining. Maskoid can be applied to mask a dry print. Dyes, toners, and stains are most consistently successful when applied to a wet print.

The Procedure

1. Begin with a completely processed and well-washed print.

2. Plan your coloring, and decide in advance on an order to follow when applying colors. Oil paints cannot be applied to a wet print, and unevenness results from applying dyes and toners to a dry print.

3. Work quickly and efficiently to avoid uneven drying.

4. Follow instructions from the manufacturers of the products, as with Marshall's oils, when you begin to work. After you are familiar with the materials, you can alter and elaborate on the basic applications for a more individualized technique.

5. Learn from each effort and apply that knowledge to your next print. Do not be disappointed with results that fail to measure up to your previsualized image. Often you will remember the accidental failures in one piece and make the accident work for you in another.

6. Experiment with all aspects of the process. Different paper surfaces will affect your techniques, as will water temperatures, humidity, and the age of the toner or coloring agent.

7. Remain patient, open, and flexible.

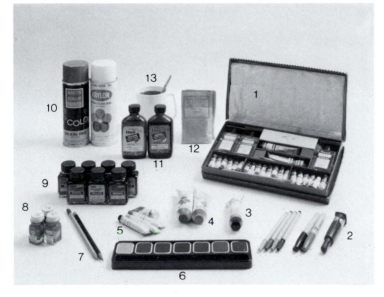

These are only a few of the possible coloring agents usable on photographs.

Coloring Agents

Coloring agents that are readily available include:

1. Marshall's Photo-Oil Colors

2. Colored marking pens

3. Artist's oil paints

4. Artist's acrylic paints

5. Artist's watercolors

6. Photo retouching colors

7. Colored pencils

8. Testor's enamels

9. Edwal Fototint dyes

10. Spray enamels

11. Edwal toners

12. Batik dyes

13. Coffee, no sugar

Colors can be applied with a brush, a Q-tip, or a piece of lintless cloth, paper towel, or sponge.

Making an Enameled Print

The print to be colored has been processed, washed, dried, and flattened. What would ordinarily be considered a finished photograph becomes a blank canvas.

Begin with a finished black-and-white print.

Toning

Toning is the first step in this coloring sequence. A portion of the print is masked out by brushing on solvent-thinned rubber cement. This masked area will remain unaffected by the toning process and will, because its silver will be unchanged, be receptive to the dyes in the next step. This masked print is toned normally in a sodium sulfide sepia toner (see the chapter on toning) and washed. The rubber cement is gently removed prior to the final wash.

The print is masked, bleached, and toned.

Blue dye is added after remasking.

The finished print is completed with enamel.

Dyeing

Dye is added following the wash. The print is remasked with rubber cement in the areas where the dye is not desired. In this example, the blue is a manufactured dye from Edwal. It will require experimentation before you will be able to evaluate effectively the degree of dyeing required and the effects of the wash following the dyeing. Mineral content in your water and your drying method will also have an influence on the final colors. The area of the print that was masked during the toning process will now absorb the dye color and the black will turn to blue. If you wish to employ multiple dyes, it will be necessary to keep masked those areas reserved for additional colors. The dyes can also be applied locally with a brush.

After washing, the print is air dried. When it is dry, the print is dry mounted so that it becomes an inflexible surface on which to apply the final color.

Enameling

Enamel is the final step in the production of this image. I employ tinted enamels in my work because of their clarity. Testor's enamels are ideal as pigmentation because of their color purity and quality and because they are easily thinned without losing their fidelity.

It is not simple to paint with enamels. A working knowledge of color, experience in painting, and a level of hand-eye coordination will be of assistance. You must use a 000 or 0000 brush to avoid air bubbles, and you should work in a quiet and dustless environment. Air bubbles and dust are obtrusive on the smooth surface of the enamels and can invalidate the illusion. The enamels dry very quickly. Any alteration of the surface should be avoided unless it is done for the sake of the image. If you are concerned with archival quality in your work, you should investigate the quality, composition, and life expectancy of any color process you use.

Alternative Methods

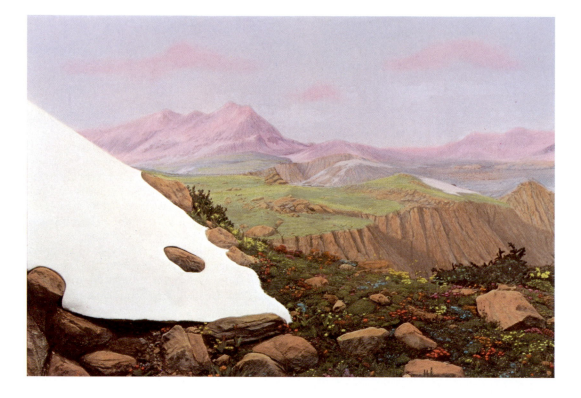

Gwen Widmer hand colored this photograph with Marshall's oils and pencils. "This method allows me maximum control to achieve an illusory quality which someone once described as 'remembered color.' My photographs are really small paintings and the overlap of the two media helps me explore the overlap of illusion and reality."

◀

Reed Estabrook applies high-quality oil paints directly on the surface of his photographs with cotton balls, Q-tips and fine sable brushes. He says that "the hand application of color provides the opportunity to have direct and tangible involvement with the making process and becomes a vehicle for the exploration of photographic references to reality."

◀

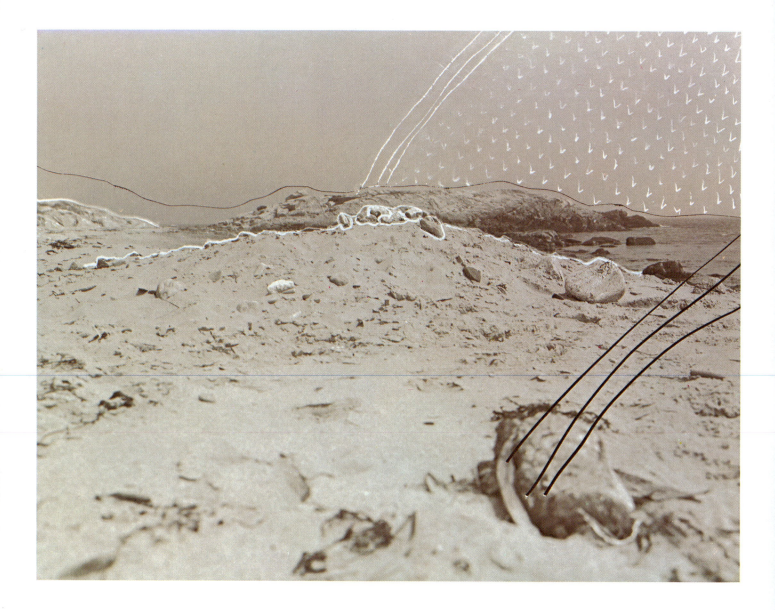

TONING
Gary Hallman

Several years ago an extraordinary experience confirmed for me the range of pure sensual pleasure photographs can offer. The event was the viewing of a large group exhibition from the Museum of Modern Art in New York called "The Photo Eye of the Twenties." I found most striking the contrast between my experience of many of the images through halftone black-and-white reproductions in books and catalogs, and the presence of the beautiful prints on the exhibition walls. Although products of a variety of black-and-white processes, the prints displayed a rich range of colors characteristic of the unique papers or toning baths used. Clearly color, along with size and surface, helped translate the artists' intent into substance.

My own work over the last several years has incorporated large-scale prints and the use of various toning processes. I've printed on sheets of paper up to 30x40, and used toners and bleaches, both to warm the image and to call attention to the flatness of the photograph. This process expands the expressive range of the photograph and plays off the dimensional illusion of the photograph against the very real two-dimensional surface of the paper. These visual attributes, along with my not quite knowing the final result until the very end of the process, have been consistent factors in my work.

Print Color With Toning

Photographers using black-and-white materials have at their disposal three methods of color control through chemical manipulation of the emulsion. The first of these is independent of any toning: simply the combination of printing paper and paper developer used. This is a subtle control, but quite important if one or a combination of the other two methods is also used. The remaining two methods of color control comprise the subject of this chapter: the two main divisions of chemical toners.

Chemical Toners

Replacement toners work directly on the silver in the emulsion by replacing or partially replacing it with inorganic salts. These toners are characteristically stable, but provide only very subtle and muted colors.

Mordanted dye toners contain a dye base that is affixed to the silver in the emulsion through the action of a mordanting chemical. Mordants, such as potassium ferricyanide, act as anchors or catalysts to allow the use of dyes that otherwise would not combine with silver. This gives the dye toners the advantage of providing a broad range of vivid colors. On the other hand, the dyes are often lacking in long-term stability, particularly on prolonged exposure to light, and they tend to be more soluble than do other toners in the final wash. Often the paper base retains traces of the dye color even after a thorough washing.

With a sensitive scale, a formulary, and an assortment of chemicals, the spectrum of print hues available by toning is broadened considerably.

These are some of the readily available packaged toners.

Your selection of paper and print developer will have a significant effect on the final color of your toned print.

Papers

The results of any toner on your prints will be very much influenced by your choice of paper. The innate tone of photographic print materials can vary considerably over a range of browns and blacks. Also, the image tone of a paper is greatly influenced by your choice of developer and its dilution, age, and temperature.

Toners will respond to different papers in markedly different ways. A toner that is particularly satisfactory on one paper may be ineffective on another. Agfa Portriga-Rapid paper develops to a warm-black image tone in Kodak Dektol developer, and to brown in Kodak Selectol. Developed in either, prints on Portriga-Rapid respond noticeably to selenium toner. Agfa Brovira or Kodak Kodabromide, papers with cool image tones, show less color difference when processed in the same two developers, and barely respond to the selenium toner.

Toners of commercial manufacture are normally accompanied by recommendations for use, but experimentation on your own is the only satisfactory way to become proficient in using them. Most paper emulsions, even contrary to the recommendations of manufacturers, will respond in some way to most toners.

The procedures discussed in this chapter apply to the use of both replacement toners using inorganic salts and mordant dye toners. Some of the more commonly used toners are listed. Several of these are available in prepackaged form, liquid or powder. You can formulate others from published information with available chemicals and an accurate scale.

Toner Chart

The chart of toners on the opposite page suggests an impressive range of colors. Inherent within this system of coloring photographs, unfortunately, is one major limitation. Each toner-paper combination yields a relatively fixed color. Thus, the color becomes a predetermined consequence of those chemicals and materials you have chosen to combine. If your initial results are not satisfactory, change your choices of paper, dilution of toner and developer, print exposure time, or print development time, until a new combination of adjustment produces a better tone.

Final toning results can be adequately evaluated only after the toner has had time to react fully with the emulsion silver. Many toners have a residual toning effect and will continue to work well beyond their removal from the toning bath. Even very low concentrations of Kodak Polytoner, for example, can continue to act for up to an hour after the print is removed from the toning bath. As you become familiar with the materials, you will learn to anticipate the color you want in advance of the effects of final washing and drying steps.

A Few Precautions

It is essential that any photographic darkroom be well ventilated. Gases or fumes released from photographic processes, including toning, not only are foul smelling and annoying, but in an unventilated darkroom become serious lung irritants. Sulfur dioxide gas released from Kodak Polytoner, some sepia toners, and some fixing solutions should be exhausted. A particularly effective green toner, GAF #251,

mixed from formula, must be used only in a well-ventilated space. This toner contains hydrochloric acid in a solution of sodium sulfide, which releases toxic hydrogen sulfide gas.

Not all darkroom chemicals constitute extreme health hazards, but all should be treated as such until proven otherwise. Selenium toner contains poisonous selenium metal ions, and the package warns against ingestion. Although there remains some question whether the toner is adsorbed through the skin, it is certainly transmitted through any cuts or breaks in the skin. This risk is eliminated by wearing rubber gloves when handling prints in selenium toner. In fact, it is advisable to wear gloves when handling prints in any toner.

Formulating Your Own Toners

A practical piece of equipment for any photographer is a gram scale or balance. With a scale and a selection of chemicals, you have a wide variety of toners readily available. Aside from the convenience, mixing your own toners allows you to explore possibilities unavailable in packaged form, guarantees absolutely fresh solutions, and removes some of the mystery behind photographic chemistry. The scale can be useful for mixing any of your photographic solutions, from developers and fixers to non-silver emulsions.

As a final precaution, when formulating your own toners incorporating acids, always add the acid to water, never water to acid. Carelessness can result in surface boiling, which spatters the acid.

Toner	Number of Baths	Color	Temperature (C)	Availability	Primary Recommendation: Warm-tone Paper (W) Cold-tone Paper (C)	Recommended Adjustment to Print Exposure or Development
1. Edwal Toners	1	Red, green, blue, yellow	20°	Bottled liquids	W/C	+dev.
2. Gold Toner, Ilford T-4	3	Red	20°	Formula	W/C	normal
3. Green Toner, GAF #251	3	Green	20°	Formula	W	+exp.
4. Hypo Alum Sepia Toner	1	Sepia brown	50°	Formula	W/C	+exp. +dev.
5. Iron Blue Toner	1	Dark blue/blue-green	20°	Formula	W/C	−exp.
6. Kodak Blue Toner	1	Light blue	20°	Packaged liquid and powder	W	normal
7. Kodak Brown Toner	1	Warm brown	20°	Bottled liquid	W	+dev.
8. Kodak Gold Toner (Nelson), T-21	1	Brown	43°	Formula	W	normal
9. Kodak Gold Protective Solution, GP-1	1	Blue-black (archival)	20°	Formula	W	normal
10. Kodak Polytoner	1	Light pink to red-brown	20°	Bottled Liquid	W	normal
11. Kodak Polysulfide Toner, T-8	1	Dark brown	20° or 38°	Formula	W/C	+dev.
12. Kodak Rapid Selenium Toner	1	Cold brown to purple-brown	20°	Bottled liquid	W	normal
13. Kodak Single Solution Dye Toner, T-20	1	Determined by dye	20°	Formula	W/C	normal
14. Kodak Sepia Toner	2	Yellow-brown	20°	Packaged powder	W/C	+exp.

Note: All these formula toners, and others, are available in *The Photo-Lab Index*, Morgan and Morgan.

Preparing Your Prints

Printing and Developing

Before printing or toning any final prints, make a series of tests with the paper and chemistry you expect to use. Many toners affect density or contrast on the print as they act. Determine in advance whether your particular paper-chemistry system will require an adjustment of either printing or development time in preparation for toning. For example, Kodak Rapid Selenium Toner has an intensifying effect on some papers, making well-printed photographs look better. In the iron blue toners containing ferric ammonium citrate, prints darken slightly from the toning; they should be given less exposure to compensate for the increased density of the final toned print. Sepia toners, including the hypo alum sepia toners, reduce the print slightly and require a somewhat dark print. Only testing in your own darkroom will allow you to predict accurately the results of your toning.

Stop Bath

After development, prints to be toned should be placed in a standard acid stop bath according to manufacturers' recommendations; 30 seconds with continuous agitation should be sufficient.

Fixing

Proper fixing is essential. Underfixed prints, or prints fixed in an exhausted fixing bath, will often stain in toning because of unremoved silver halides or silver thiosulfide compounds in the emulsion. Although much less troublesome, overfixing eventually leads to bleaching of the prints, and offers no advantages. Kodak Rapid Selenium Toner diluted 1:9 is useful as a test solution for residual silver compounds. Squeegee the print you wish to test, and place a drop of the toner solution on a section of white print margin. Any trace of color more than a barely visible cream tint after 2 or 3 minutes indicates the presence of residual silver compounds in the print, the result of inadequate fixing or washing or both. Stains will occur randomly on any inadequately fixed print during toning. The use of two fixing baths, standard procedure for many careful photographers, helps guarantee well-fixed prints that will tone evenly and wash to archival standards more readily. The two fixing baths are used in succession on each print, half the total time in each. The first bath will exhaust first. When it is exhausted, discard it, replace it with the second bath, and mix a fresh second bath. Hardeners in the fixing baths can also affect the result of later toning. Again, only tests with your own materials can adequately guide you.

Washing

After fixing, rinse the prints for a few minutes in running water and transfer them to a washing aid or fixer remover. Agitate them for 5 minutes; then follow with a 10-minute running water wash. They should then be free enough of residual silver compounds to tone.

Selenium toner can be used in a solution of a standard washing aid and Kodalk or sodium metaborate, immediately following the second fix bath. The addition of Kodalk to your fixer remover formula, 20g per liter, helps neutralize the fixer absorbed by the paper. This solution should be used only if the print is transferred to it immediately after the fixing bath, without a rinse. Used any other way, the Kodalk can cause a pH imbalance in the paper, generating small amounts of gas in the paper that can cause blistering of the emulsion. If this method produces stains, return to separate toning after the wash steps.

I find the printing and toning processes easier if divided into two separate operations. After fixing, rinse the prints; then transfer them to a holding bath for the duration of the printing session. The holding bath should be a tray of regularly changed or running water.

After printing is completed, turn your complete attention to washing and toning.

If desired, prints accumulated in the collecting tray may be given a 5-minute wash and stored in a tray of water overnight for completion of the toning process the following day. If you wish to tone prints that have been dried, they should be immersed in water for at least 5 minutes before being placed in the toner. If the prints are not thoroughly wet, the toner will be absorbed unevenly, giving mottled results.

Temperature and Agitation

With the exception of a very few toners that must be used at high temperatures, most toners are recommended for use at 20° C. Temperature is not usually a critical factor, and toners can be used at room temperature. Temperature affects little beyond rapidity, higher temperatures causing faster toning. Continuous agitation, as normally given prints in development, is appropriate for toning. As controls, concentration and duration of the toning bath are most significant.

Toning Your Prints

Toning for Permanence

Part of the difficulty in protecting black-and-white photographs for longevity is the susceptibility of the image-forming silver itself to atmospheric pollutants. Just as any piece of silver jewelry or flatware will eventually tarnish, a photograph will stain or degrade, particularly in the presence of airborne sulfur compounds.

Certain metal-replacement toners, particularly selenium and gold, replace or coat the silver in the emulsion with a more stable, less reactive metal. A gold toner will protect a silver photographic image in the same way a gold-plated silver chain is protected from tarnish.

Gold compounds for toning are quite expensive, and aside from use with silver chloride printing-out papers that require a gold toning bath before fixing, they produce little or no visible effect.

Selenium, however, widely used as a protective toner, has the additional advantage of slightly increasing the tonal range of the print. By bonding with the silver in the image, it slightly increases density, more in the shadows than the highlights, giving the print a richer, darker black tone.

Used in a dilution of 1:30 for 3 to 5 minutes, Kodak Rapid Selenium Toner will protect and very slightly increase the print contrast without a significant color change. Used in higher concentrations, selenium toner will add a range of purple shades to your toner palette, in addition to its normal effects on contrast and permanence.

Toning for Color

After your prints are thoroughly washed, they are ready to be toned. The process of toning is a very easy one. Packaged toners and published formulas are all accompanied by specific suggestions and instructions on their use. Therefore, with the exception of some specific toners and dilutions, the following discussion can be applied generally to all toners.

A minimum of three trays is required for a single-bath toning solution. One is a holding

tray for prints to be toned, one contains the toner, and one serves as a collecting tray for toned prints. If you are doing more than a few prints, an extra tray or two of rinse water after the toning tray will reduce the amount of toner successive prints will transfer with them into the final collecting tray. Remember that any amount of toner remaining in contact with the emulsion, including toner absorbed by the paper fibers and accumulating in the collecting tray, will continue to act upon the silver in the emulsion.

Take care not to splash or spill any toner onto prints in the holding trays. Even if the effect is not immediately apparent, the toners will begin working, possibly leaving you with noticeably overtoned spots on your prints.

When working for subtle tones with some toners, such as highly diluted selenium, the natural adaptation process of your eyes presents a major problem. As you watch the print in the slow-acting toner, one moment the color seems totally unchanged, and the next, it seems grossly overtoned. The only way to detect the minute changes in a gradual toning is to provide yourself with an identical untoned print, in a tray of plain water, as direct comparison with the progress of the print in the toner.

Manipulating Toners

If you are interested in localized toning, or multiple colors on a single print, toners can be selectively applied to specific areas. Squeegee a well-washed print onto a piece of Plexiglas or glass or the cleaned back of a flat plastic tray. The face of the print should be well squeegeed and free of droplets. You can then apply concentrated toners with cotton swabs, brushes, or small pieces of sponge. A few drops of Photo-Flo added to the toners will help prevent beading on the print surface. Apply one toner at a time. Rinse and squeegee again before reapplying the toner for richer effect, or adding a second color. It is difficult to achieve an even tone with hand-applied toner. More dilute solutions will help but will require multiple applications.

Ordinary rubber cement or Maskoid can be applied as an emulsion mask directly to any areas of the damp print you do not wish toned. The masking will prevent, for a short time, any toner from reaching the covered area. Prolonged immersion will allow toner to seep under the edges, or through the back. By peeling or rubbing off the mask, and then reapplying it, prints can accurately be polychromed.

Finishing Up

Washing

After toning, prints require thorough washing. Wash times vary for different paper–toner–washing aid combinations. The most reliable method of determining wash times for permanence is to test your washed prints with the Kodak ST-1 test for residual silver (*Photo Lab Index*, Morgan and Morgan) and HT-2 for residual hypo (*Procedures for Permanence*, East Street Gallery, Grinnell, Iowa).

For toned prints on double-weight paper, I recommend a 5-minute water wash, then a washing aid for 2 minutes, followed by a final wash for approximately 40 minutes. Warmer water washes better, but the fragile emulsion can be damaged by heat. Wash water at about 24° C is the most effective without presenting a potential hazard.

If you mistakenly place untoned prints in a washing aid once used for toned prints, they can be visibly affected by residual toner in the bath. To be certain of having no color bleeding or carryover, prepare a separate washing-aid solution for each different toner, as well as for untoned prints.

With experience, you will find that toners work in a predictable fashion. Some characteristic difficulties to watch for include excessive solubility of some toners in the wash, and reactions of some toners and washing aids on one another. Most mordant dye toners are susceptible to long washes; a degree of overtoning will help compensate for color loss during the wash. When transferred to a washing-aid bath, prints toned in sepia toners may be slightly intensified or shifted in tone, and those toned in blue toners may be reduced in intensity. A quick test will tell you to what extent, if any, the solution you are using may affect these toners. Iron blue toners are also susceptible to fading during wash in water of neutral pH; most formularies suggest the addition of a few drops of acetic acid to each change of wash water, lowering the pH to maintain the intensity of the blue tones.

Storage

With the exception of hypo alum sepia toner, which improves with age, most toning solutions, once diluted and used, cannot be reliably stored. Rather than take chances, mix enough fresh solution for the number of prints to be toned each session and discard after use.

Summary of Processing Steps

1.	Develop	Select paper and developer for match with toner	1½ to 5 minutes
2.	Stop	Standard acetic acid bath	30 seconds
3.	Fix (1)	Use fresh fixer, hardening or nonhardening. Do not overfix.	3 to 5 minutes
4.	Fix (2)		3 to 5 minutes
5.	Rinse	Plain water	2 to 5 minutes
6.	Washing aid	Perma Wash, Orbit Bath, Kodak Hypo-Clearing Agent, etc.	2 to 5 minutes
7.	Wash	Running water	10 to 40 minutes
8.	Toner	Three trays minimum, for one-bath toner	as necessary
	Tray 1	Fresh-water holding tray	
	Tray 2	Toner. Normal agitation	
	Tray 3	Collecting tray. Change water frequently or use running water.	
9.	Washing aid	Separate solution for toned prints. Pretest for intensifying or bleaching.	2 to 5 minutes
10.	Wash	Running water	20 to 40 minutes
11.	Dry	Air dry on plastic window screen	

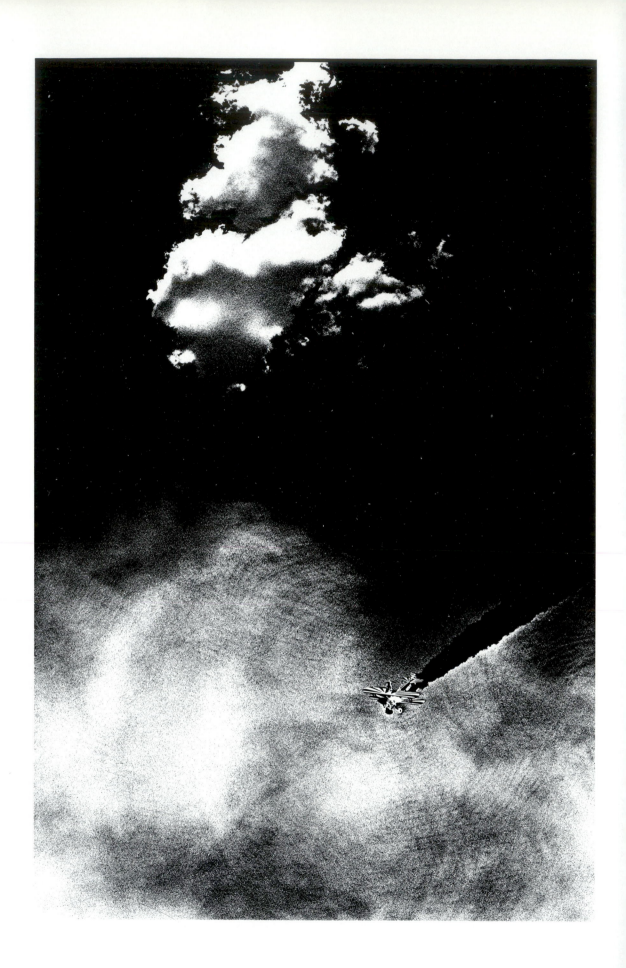

HIGH CONTRAST
J. Seeley

Before a photographer can begin to create personally meaningful images, he must establish a relationship with his materials and techniques. Perhaps because I came to photography from printmaking, I felt the need to slow the photographic process down. I wanted to generate my images in stages.

Working time is a crucial factor in my creativity. Typically, with conventional photography, the game is over in one-sixtieth of a second. After that initial instant of exposure, the photographer's efforts are directed almost exclusively towards its preservation. The image has been recorded and the photographer has, while developing and printing, relatively little opportunity to improve it.

I discovered that by combining high-contrast emulsions with my own photo-collage techniques, I can slow the photographic process down to a comfortable speed. I use high-contrast litho film as an intermediate step between my original continuous-tone negative and my final print. While this introduces the complexity of additional steps, increased complexity is the price paid for increased control.

When I work, there are few "decisive moments." Indeed, there are many indecisive ones. I don't like to make all my decisions at the shooting stage. After I have exposed a negative and proofed it, I work slowly, continuing to make decisions and transformations.

Litho film is well suited to my personal visual interests and to my work habits. I am fascinated by the extensive visual possibilities it offers within the inherent limitations of the medium. Because it is a film, it can be effectively reversed from positive to negative and back again. It can be cut, scraped, scratched, sandwiched, painted on, drawn on, and otherwise mutilated in a variety of ways.

Rarely do I look for, or shoot, complete images. I think of myself as a collector of interesting fragments. Later, these fragments are integrated, and often simplified or purified, by translation to litho film. I usually work on a dozen pieces at the same time, often combining new images with old ones. Occasionally, an image in process will be set aside for a year or two until I can find the missing link that completes it.

Many critics regard high-contrast photography as a gimmick, a trick used to save an otherwise dull picture. One of my college instructors described it as "a fad." In that same year, 1967, I think it died as a fad. When you experiment with a process, if the final image is unsuccessful, the technique is likely to be branded a gimmick. If the final image is strong, the technique will be hailed as innovative.

Any such label is of course simplistic. High-contrast film is a medium within a medium. I am constantly amazed at the variety of images possible with this material and at the individualistic character of the images produced by different photographers using it. Sadly, few photographers use high contrast creatively. But this medium is still relatively new, and the future will certainly bring further refinement of high-contrast photography as an art form. As in any medium of artistic expression, the end product can only be as expressive as the artist.

How to Make a High-Contrast Print

The procedure described below is a simple method of transposing an image from a continuous-tone negative to an extremely high-contrast film: litho film. A litho negative can be effectively enlarged onto photographic paper, a conversion that will transform all tonal values to total black or total white. Neutral gray tones are either dropped out of the image entirely or reduced to distinct black granular dots.

Litho film is available in standard and extra-large sheet film sizes. It can be handled in the darkroom under red safelight, as though it were photographic enlarging paper. It is fast enough to respond to either enlargement or contact printing.

Most people associate the word *film* with a negative image that comes from the camera. In the same way, the word *print* is associated with a positive image on paper. Actually, either a positive or a negative image can be recorded on either paper or film. When working with litho film materials, it becomes necessary to transfer images both positive and negative. Most continuous-tone and litho films are negative-acting materials and will reverse the tones in the image they receive.

To produce a final high-contrast print from a continuous-tone original negative, two intermediate steps are necessary: a positive image is made by printing the original negative onto litho film; then that film positive is transferred, by contact printing, to a second piece of litho film. The resulting high-contrast negative can be projected onto enlarging paper for a final print.

This print of a model dressed in striped clothing was made on normal-contrast paper from a Tri-X 120 negative.

The graphic simplicity of this print, made from the same 120 negative, is the result of a darkroom conversion onto litho film.

The Materials

1. Contact Frame. Basic darkroom equipment is sufficient for most work with litho film. Because a good deal of contact printing will become necessary, a spotlessly clean, tight-fitting print frame is necessary. A vacuum frame is even better, if you have access to one.

2. Litho Film. Several manufacturers produce litho film under a number of brand names for use in the printing industry. The best-known and most readily available is Kodalith Film, manufactured by the Eastman Kodak Company. Other manufacturers of litho film include DuPont, GAF, 3M, and Agfa. Litho film can be purchased from any photo supplier that carries a graphic arts line. Because each manufacturer produces many types of litho film, it is best to ask either for a specific catalog number or for the most basic type a supplier might stock.

3. Litho Film Developer. In addition to the film, a special developer is needed. There are several commercially prepared litho developers, which are similar and often interchangeable. It is advisable, however, to use the developer recommended by the manufacturer for the litho film you have selected. It should be mixed and stored as the directions indicate.

4. Safelight. Most litho films are orthochromatic, or color blind to red. Use red ortho safelight filters. The Kodak filter is designated 1A.

Setting Up

Begin by changing your safelight filters. A safelight about 1.5 meters above the developer and another near the enlarger should be equipped with 1A filters. All other standard yellow safelights will be safe if kept at a distance of at least 2.5 meters from the film.

The chemical setup is simple. With the exception of the special litho developer and a simplified wash technique, processing is the same as for conventional black-and-white printing. Use flat-bottomed trays slightly larger than the size film you intend to use.

The litho developer parts A and B, if they are purchased in powder form, should be mixed separately and allowed to cool to room temperature before use. A working solution of developer is prepared by mixing together, in the quantity needed, equal amounts of A and B stock solution. There should be solution in the tray to a depth of at least 15mm. The combined solution begins gradually to exhaust after 30 min at a rate determined by the use and amount mixed. It should comfortably develop the equivalent of fifteen 8x10 sheets per liter.

A standard stop bath and paper-strength fixer follow the developer. All chemistry should be between 18° and 24° C. A deep tray is sufficient for washing. A final tray should contain a film-strength solution of a wetting agent, such as Kodak Photo-Flo.

Special materials needed to make prints on litho film.

Making a Film Positive and Negative

Making a Film Positive

1. Set up your enlarger as you would to make proof sheets. Several frames of your negatives can be exposed simultaneously, but it is best to begin by testing one at a time to determine accurately the best exposure time.

2. Dust the print frame and negative carefully

3. Place unexposed litho film below the selected negative, emulsion to emulsion, in the print frame. The lighter-colored side of the litho film is the emulsion side.

4. Expose after placing the print frame under the enlarger and setting the timer. The exposure time will be approximately the time you would use for proof sheets on photo paper.

5. Develop the film. Slip the exposed film into the developer, emulsion side up. Rock the tray very gently to provide adequate agitation; rocking can be done by randomly lifting corners and sides of the tray. Full development, which results in total opacity in the dark areas, should take between 2 and 2½ min. Slight overdevelopment can be tolerated in some images, but underdevelopment will result in streaks. As the development begins, there is no visible image for the first half minute. Gradually, a faint image begins to appear. The image will darken at a uniform rate for an additional 1 to 1½ minutes. Watch the white areas of the image. When development is complete, they should show a barely perceptible trace of brownish-pinkish tone. If the image comes up too fast, reduce the exposure time and try again. Insufficient density after 2½ min of development indicates a need for increased exposure time.

6. Lift the film out by one corner after development is complete. Let it drip for 2 or 3 sec, and put it into the stop bath.

7. Stop bath. Gently agitate the film in the stop bath for about 10 sec, then transfer it to the fixer.

8. Fix the film. Agitate the film in the fixer gently and constantly. After about a minute the light areas of the image will begin to clear. Make a mental note of the amount of time it takes to reach total clearing. The total fixing time should be at least twice the clearing time.

9. Rinse the film and inspect it against reflected white light. Accurate judgment of the developing time requires some experience. Our eyes are relatively insensitive to red light, and the density will appear much greater in the developer than it will against the white light. It is always necessary to check the image in white light after fixing.

10. Wash the film in a deep tray for 3 min. For films that must have a long life, such as a final litho negative, the wash time should be increased to a full 10 min. If several film prints are to be washed, it is best to wash them one at a time to avoid scratching.

11. Photo-Flo and dry. After washing the film, immerse it in the wetting agent solution for 15 sec; then hang it by one corner in a dust-free area to dry.

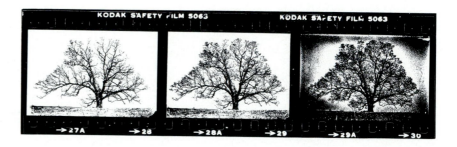

This is a film positive made by contact printing the original camera negative on litho film.

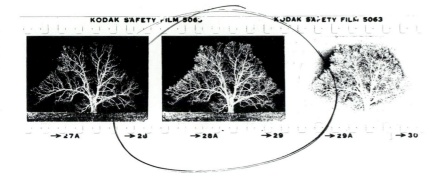

This film negative was made by contact printing the film positive shown above on another piece of litho film. It can now be trimmed and enlarged on conventional photographic paper.

Making a Litho Film Negative and a Final High-Contrast Print

1. Contact print the completed and dried positive, emulsion to emulsion, with a fresh piece of litho film.

2. Repeat the same processing procedure.

3. After the negative is dry, trim it to fit into the enlarger's negative carrier. This high-contrast negative can be printed on almost any type of enlarging paper.

4. Your own standard chemical setup for paper printing can be used to produce high-contrast enlargements on paper. Richer blacks can be obtained by mixing a stronger developing dilution, for example, Kodak Dektol 1:1.

Contact prints on litho film can be trimmed to fit your enlarger's negative carrier. This is particularly handy if your enlarger will not accommodate sheet film sizes.

If you are using litho film for the first time, begin by using the basic technique for producing a high-contrast print as an exercise, to gain familiarity with the materials. With some experience it is possible to intensify or subdue certain images by modifying this process. Any experimental technique that is applicable to conventional film or paper can be successfully applied to litho film. In addition, there are several processes that are unique to high-contrast film. The modifications described in the following pages demonstrate the versatility of the film as a creative material and represent a few of the numerous aesthetic decisions that must be made as complexity is introduced into the medium.

Enlarging the litho film negative shown above results in this final high-contrast print.

Selecting a Working Film Size

One of the first decisions you must make concerns the treatment of detail. Often you must choose between detailed description and abstraction of the subject. The size of the intermediate film prints used will have a profound effect on the quality of the image. The basic method described on the previous pages utilizes the least amount of film and produces the greatest degree of image simplification, particularly if the original negative is 35mm.

If a great deal of detail in the image is desired, and you can afford the film, enlarging from your original negative onto a large piece of litho film will give a much greater amount of detail than simple contact printing. An 8x10 litho enlargement can be contact printed on a second piece of film. This final negative can be printed by contact with enlarging paper for the final print. With this modification of the technique, a considerable amount of detail will be carried in the tone areas. Gray tones will be represented by the grain patterns recorded on the original negative. These patterns, rather than being soft, blurry gray dots, as they would appear in a continuous-tone print, become hard-edged black dots. Accurate enlarger focusing on the litho film is critical.

Intermediate levels of detail and tone can be held by intermediate-sized internegatives. Many prefer, for aesthetic and economic reasons, to do most internegative work on 4x5 film and then enlarge the last step. The contact and enlarging modes of image transfer can be mixed together in several combinations, depending on the exact degree of detail rendition you desire.

The care with which you focus your enlarger affects both the sharpness of image detail and the overall contrast.

114

This magnification shows the appearance of grain in a properly focused print.

Only a slight shift in enlarger focus was required to change the appearance of the grain this dramatically.

Basic Darkroom Controls

A Good Film Print

A good litho film positive or negative should not transmit light through the dark areas. The first positive may show a very slight brownish tone, but if it is overly brown, it indicates underdevelopment or exhausted developer. There should be no evidence of streaks or wave patterns.

A few clear specks will be present in the dark areas of the film. These are caused by dust particles settling on the film during handling, and occur even in the cleanest of darkrooms. If these dust specks, or pinholes, are extensive, reclean the film and glass contact surfaces.

Ordinarily, all film prints should be sharp. There are two major causes of unsharp prints: lack of precise enlarger focus and poor contact in the print frame. Litho film is very particular about the sharpness of the detail it receives: the slightest blur will have a drastic effect on both the detail and the contrast in the final image.

The result of good printing-frame pressure throughout the process is shown in this detail.

Uneven pressure from the printing frame between original negative and litho film can cause unsharp areas like these.

A similarly unsharp image results from poor contact between litho negative and paper in the final step of the process.

Detail in the car was washed out by exposing correctly for the tree area during printing from the negative.

The Effects of Varying Density by Exposure

Normally, the exposure and development of litho film should be sufficient to keep the light areas of the image totally clear and the dark areas totally opaque. It is possible, however, within these limits, to vary the distribution of these blacks and whites by varying the exposure time.

As with conventional enlarging, increased exposure will yield a darker image. Density affects both the mood and the tone distribution. Decisions about density should be made in the first stage of transfer to the high-contrast film. Any major modification after that time can be made only by retouching. Enlarging time and not development time should be considered the main variable. The length of development should be regarded only as a subtle control.

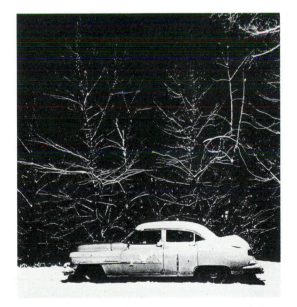

When an exposure is used that reveals detail in the car, the tree area drops into darkness.

Through the use of conventional burning and dodging techniques, all areas of the print are allowed to show detail. The foreground area was given extra exposure, and the trees in the background were given less than normal.

Retouching Litho Film

Litho film is a rugged material and can withstand retouching in either its positive or its negative state. Retouching, at its simplest, consists of painting out the small dust specks on the final negative. In its more complex application, however, retouching can be used to transform completely the content and character of the original image. Your own application of these techniques will depend on your skill, patience, and visual interests.

Retouching Materials

Most of these materials are available from larger art supply stores:

1. Small bottle of red liquid opaque.

2. A #2 or #3 sable detail brush.

3. Medium size X-acto knife with #22 blade.

4. Large sewing needle or lithographer's scribing needle.

5. Cellophane tape of good quality.

6. Roll of red lithographer's tape or black opaque masking tape.

• Lighted surface to work on, such as an x-ray or slide viewer or light table.

• Black construction paper or orange plastic litho mask.

Opaque

Opaque is a red, claylike, masking paint available from most graphic arts dealers and some art stores. It is possible to use it directly from the jar, but if you intend to do very much work with it, it is best to prepare it as professional lithographers do. Stir it completely and pour it into a shallow plastic container. Small plastic lids, such as the type that top a small can of peanuts, will work well for this purpose. This pooled opaque should be allowed to dry for about two days before use. Then drip a

Materials needed for retouching litho film.

few drops of water into the middle of the dried cake, and gently swish the water around with the detail brush until the liquid reaches the consistency of light cream. Turn the tip of the brush to form a point. Apply the opaque in a single, even stroke. In the places where the opaque is applied, light will be blocked from transmission through the film. Thus, scratches and dust specks can be easily blocked out in opaque areas. In fact, any detail you wish to block can simply be painted over. The solution should be applied thickly enough to cover evenly in one stroke. If it is too thick it will crack off or interfere with the contact-printing process. If it is too thin it will not adhere to the film.

If extensive retouching is required, work on a glass surface lighted from below, such as a transparency viewer. There should also be some overhead light so that you can see the paint on the tip of the brush.

Opaque dries rapidly unless the work area is extremely humid. If desired, drying speed can be increased by adding three or four drops of rubbing alcohol to the opaque paste.

Orange plastic lithographer's masking material, available from a printers' supply store, provides an easy way to mask out large areas. It is completely opaque to the unexposed film, and is easily cut and taped in place.

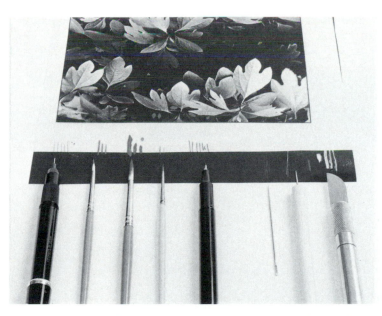

Retouching tools and the marks they make. From left to right: technical pen with acetate ink, three small brushes with opaque, permanent marker, sewing needle, lithographer's scriber, X-acto knife with #22 blade.

It is usually best to do opaquing work on the base side of the film. The solution is water soluble and can be removed with a damp cloth if you make a mistake.

Opaque is most efficiently used for small detail or edge areas. Larger areas should be blocked by the application of black or red tape or an orange mask cut to fit the shape of the particular area.

It is possible to purchase special felt-tip pens containing a red lacquer intended to serve the same purpose as opaque. Their convenience is questionable, as it often takes two coats to block light transmission adequately.

Scraping and Stippling

Some photographers prefer to work with chemical reducers to remove unwanted areas on the film. Because of the density of the litho image, it is easier and less complicated to mask out unwanted areas or neatly scrape the emulsion from the base of the film with an X-acto knife, which must be equipped with a rounded #22 blade. The very tip of this blade, held at the correct angle, works well for removing even the smallest details.

You can simulate small areas of grain on the film by using the point of the blade or a lithographer's needle to make little nicks through the emulsion. This stippling technique, similar to spotting a final print on paper, is useful for camouflaging imperfections in the granular areas.

Drawing on Film

Litho film is an ideal medium for combining photographic and hand-drawn imagery. Drawing can be imaginatively added to internegatives by using a large sewing needle to scribe through an opaque area. You can draw on clear areas with a thin-nibbed opaque lacquer pen or technical pen filled with ink suitable for drawing on acetate. It is even possible to draw on the litho film prior to development with a masked penlight flashlight. As the state of the image is reversed, the orientation of the drawing also changes: white lines on black become black lines on white, and vice versa. Drawing can also be used to repair or reconstruct partial images.

Photomontage

The high-contrast process lends itself to composite application. The similarity of rendition can give shots taken at different times and places an increased visual compatibility. This montage technique is based on methods and materials used by printers in preparation of art work, photographs, and type for offset printing.

Arrange and study fragments or complete photos, selected and printed to final size, on a clean sheet of clear acetate until you achieve a desirable composite image. The acetate sheet should be the full size of the final print. Then secure the pieces in place by neatly taping them down, emulsion side up, on the acetate. Use small pieces of cellophane tape, and do not let

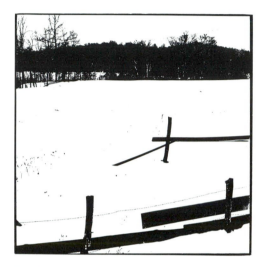

The fence will be cut with scissors from this enlargement on final-size litho film.

The plant on this sheet of film will be extracted and combined in the next step with the fence.

The two selected fragments and the border are secured in place on an acetate sheet with cellophane tape.

The acetate paste-up is printed on litho film. The very light lines caused by the cut edges and cellophane tape that show up on the negative can be painted out with opaque before the final print is made.

The retouched film negative was used to make this final print.

the tape edges cross image areas. You can produce a thin frame by using 1/64" chart tape applied to the back side of the acetate; a piece of graph paper placed under the film is useful as a guide for positioning the tape lines. You can also draw border lines directly on the acetate sheet or scribe them through the film in the negative state.

When the montage is complete, contact print the acetate and its attachments, emulsion to emulsion, on a piece of litho film. You will need to opaque out the thin lines formed by the cut edges and the cellophane tape, along with the dust specks, before contact printing the final negative on photo paper to produce the final image.

Composites can be made in either the negative or the positive contact film stages. Positive and negative elements can also be applied to the same work. It is often useful when making a complex montage to make one or two extra contact film printings along the way to check on the progress of the imagery and aid in retouching as you work. This is possible in most images because there is very little quality lost in the introduction of extra film generations.

Three different camera negatives went into this simple composite. The litho film caused the tone of the snow to drop out entirely. The split-framing, which does not indicate the original shape of the frame, has been used as a design device.

Photomontage Examples

The weeds and the bird were photographed separately, silhouetted against a light sky to provide a white background. The borders were created using chart tape, and the film fragments were assembled inside them.

Six different camera negatives were used to
make this complex composite image. The
forest was generated from three different
photographs of one toy tree. The spaceship
negative was made of an old metal toy. The
vapor trail was extracted from a photograph
of a real airplane doing aerobatics. The star
negative was generated by photographing
pinholes in a backlighted sheet of paper with
the camera intentionally out of focus. The
spaceship, the vapor trail, the sky, and each
tree were separate components, and assembling
them required great patience and attention
to detail.

Masking

Masking is the most complex process described in this chapter, but it is actually more difficult to think about than it is to do. You can incorporate an image within a different background, other than pure black or white, by a series of steps known as masking. These steps are necessary to create a clear area in the background film into which to insert the foreground image. This clear space must exactly match the outline shape of the foreground object. Accordingly, the technique requires skill in hand brush work to accommodate anything but the simplest shapes.

The first step in the process is printing the foreground object, in positive, against a clear field. It helps if the object was photographed against a bright sky, snow, or a white backdrop. To avoid having to retouch cut lines, it is best to print the object in the size and location it will occupy in the final print. There should be a clear field the total size of the final print surrounding the object. When this piece of film is dry, completely opaque out the object on the base side of the film. If the original object is in silhouette, there is very little opaquing work to do, since the objective is to create a total silhouette. This silhouette against a clear field serves as a mask as it is contact printed against a negative litho print of the desired background. The resulting film print is a positive background with a clear space for the foreground image.

Remove the opaque carefully from the foreground image with a damp cloth. Dry this film and then accurately register it to the prepared background. Tape the two pieces together and contact print them to produce the final negative.

If you have skillfully opaqued the foreground object, there will be a near-perfect match. If there are small imperfections surrounding the foreground image, they can be retouched by scraping and stippling. The final negative is then ready for contact printing on photo paper.

*1. **Continuous-tone print** of a chair with a striped cover.*

*4. **Continuous-tone print** of a model posing in striped clothing on the chair. The chair itself and the model's head have been covered with a white sheet to simplify retouching.*

2. Litho film positive *enlarged directly onto final-size litho film from the camera negative.*

3. Litho film negative *made by contact printing from the litho film positive (2).*

5. Litho film positive *of the model enlarged directly onto final-size litho film from the camera negative. All remaining areas of unwanted tone were cut out or scraped off the film so that only the image of the clothing remains.*

6. Litho film positive *(5) painted over carefully with opaque.*

Masking, cont.

7. Litho film print *made by contact printing from a sandwich of the chair negative (3) and the opaqued model positive (6).*

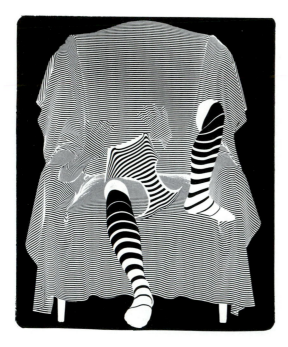

8. Final litho negative *contact printed from a sandwich of the chair negative with the clear space (7) and the opaqued model positive (6) after the opaque was washed off.*

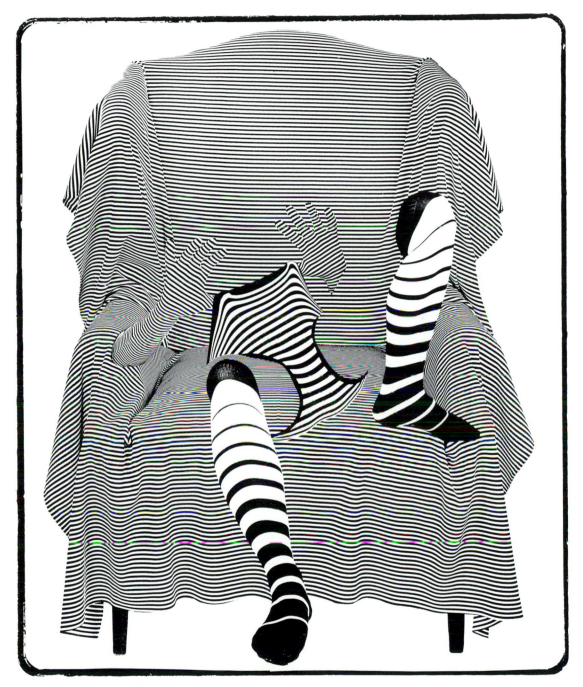

9. The final print is the result of contact printing the final litho negative (8) on photographic paper.

Tone Separation and Tone-Line

Tone Separation

Tone separation, often called posterization, is a technique of making, usually by enlargement, three or more density renditions of the original negative. See The Effects of Varying Density by Exposure, p. 117. These film positives, light, medium, and dark, are marked for registration and then contact printed to produce complementary litho negatives. Each negative carries a different tonal distribution. They can be used in several ways. Most commonly, the negatives are contact printed, one at a time and in register, on a single piece of photographic paper; the paper is developed after the three separate exposures have been made. To provide a visual separation of the three densities, the print is given differing amounts of exposure through each negative. Light, medium, and dark exposures should correspond to the appropriate negative. Extensive exposure and registration testing is required. The technique rarely produces interesting results in its black-and-white application, but the negatives can be printed through a variety of filters onto color paper or by using multicolor proofing or printmaking processes.

*1. **Litho film positive** enlarged from a normal camera negative.*

*2. **Litho film negative** made by contact printing from the positive (1).*

Tone-Line

The tone-line technique is a contact-printing procedure that will transform a high-contrast image into a line impression. The term itself is actually a misnomer: the line generated accurately describes the exterior and interior contours, but eliminates all of the tones.

By carefully sandwiching matching positive and negative litho prints base to base in a print frame, covering the frame with a sheet of translucent white plastic, and exposing the whole package, it is possible to produce a line image similar to an outline ink drawing. By registering the positive and negative base to base, transparent vertical channels are formed between dark areas on the two films. The plastic diffuses the light, redirecting it through these slots onto the unexposed litho film below and magically forming the line image.

Select a negative. Objects that are silhouetted or very graphic in appearance work well with this process.

Make a positive litho film print. It is usually best to work with 4x5 or 8x10 film.

Make a matching negative by contact printing with the positive. It is important that the two prints have matching densities.

Align the two prints base to base; use a light table if possible. If the films are of matching density and are correctly positioned, there will be a complete cancellation of light transmission when the sandwich is viewed through a lupe, or magnifier. Tape the two prints together securely with cellophane tape.

Set the enlarger lens at its widest aperture. Set the timer for 30 to 60 sec, depending on the intensity of the enlarger bulb, and raise the head of the enlarger so that it projects a light cone of sufficient size to cover the print.

Place the joined film sheets in the frame so that the layer with the greatest dark area is in contact with the emulsion side of an unexposed sheet of litho film. It is possible to substitute enlarging paper, but printing on a litho internegative allows for retouching and reversal of the image.

Place the print frame in position under the enlarger, and cover it with a sheet of thin, translucent, white Plexiglas. The design of most frames allows for sufficient space between the plastic and the glass.

Expose the print.

If you don't have a piece of white Plexiglas handy, you can obtain an identical result by manually directing the light into the clear channels of the litho sandwich. You can accomplish this by systematically making a series of exposures while holding the print frame under the enlarger at a 45° angle to the lens. The aperture should be set at f/16 and the timer between 15 and 30 sec. The timer should be activated 8 times to complete the exposure: one full exposure is made for each side and corner. The frame needn't be held perfectly still for each interval, but the 45° angle must be maintained.

3. Positive tone-line made from a sandwich of the matching positive (1) and negative (2) litho film prints. The enlarger light was directed through translucent Plexiglas.

4. Negative tone-line contact printed from the positive tone-line (3).

The thickness and detail of the line formed depends on several factors: the original film format, the quality and character of the subject matter, the size of the litho film used, the quality of the pressure contact in the print frame, and the length of exposure and development. Because of this large number of variables, experimentation is necessary to perfect the technique.

It is possible to register a positive and negative that do not have matching densities, which will produce a tone-line that varies in thickness and detail. It is also possible to combine a litho positive with a continuous-tone negative.

The first tone-line print on litho film will produce a black line on a clear field. This can be printed directly on photographic paper, or it can be reversed by contact printing on an additional piece of litho film. Retouch undesirable areas before you make a final print. An image produced by tone-line can be an effective finished print; it can be combined with tone separation; or it can become a base for drawing or other manipulations.

Screens and Backgrounds

It is possible, through masking, tone separation, or simple sandwich contact, to incorporate patterns into litho images. These patterns can be introduced in several ways, most obviously by placing the pattern or screen over the litho film and projecting or contact printing the image through it. There are commercially prepared texture screens, homemade screens, and a multitude of tone screens and patterns made for graphic artists to use in layout work. These artist's tone screens are inexpensive and can be contact printed directly onto litho film without removing the adhesive backing. Once you have printed the screen on litho film, it can be reused in either its positive or its negative state. Two or more screens can be overlapped to produce interesting moiré configurations.

The overlapping of two artists' tone screens.

Found Screens

Various other materials can be effectively contact printed directly onto litho film to produce original patterns.

Homemade screens produced by contact printing directly onto litho film include:

Lace
Fabric
Wire or die-cut screens and grills
Decorative glass
Skeletonized leaves
Spatter-painted acetate sheet
Prints from greased skin
Papers

Commercially available artists' tone screen.

Patterned paper, fashioned into a miniature room with dollhouse windows. The room was photographed and printed on litho film to create a background.

Photographed Screens

Interesting backgrounds can be photographed and combined with other images as needed. Inexpensive paperback books of full-page decorative and geometric patterns are readily available. The best approach to serious photomontage work is to make continuous-tone negatives of interesting found backgrounds as the opportunities arise.

Homemade screens photographed and then later enlarged onto litho film include:

Interior and exterior walls
Wallpaper sample books

Images from TV sets
Gravel
Roofing material
Sandpaper
Tree bark
Rock
Billboards with layers of torn paper
Moving water
Sky
Moss and other plant forms
Wood
Snow

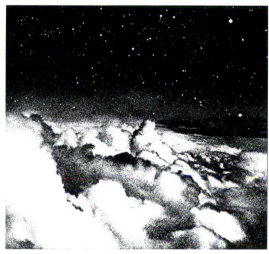

Clouds photographed from an airliner window, combined with stars fabricated in the studio.

Graph paper combined with photographs taken from a TV screen.

Raindrops on a black plastic garbage bag.

Other Applications

Further Techniques

Litho film can be used as an intermediate step for facilitating and intensifying any black-and-white and many color experimental materials and processes. It can be successfully substituted for conventional film or paper when working with photograms or Sabattier images. It can also be utilized as an intermediate step when working creatively with x-rays, infrared, dye transfer, or color proofing materials, such as Diazo, Color-Key, and Kwik-Print.

When archivally washed, the film can be used as a final material itself. The back side can be painted in, coloring-book style, with poster paints or acrylics. Litho positives can be developed in diluted litho developer or paper developer, to produce subtle brown tones. The positives, after processing, can be mounted on thin, translucent Plexiglas. Even without trans-illumination, prints of this type can produce a soft glow that is quite pleasing. Some photographers have used thick-base (4556) Kodalith in combination with clear Plexiglas sheets to produce three-dimensional photosculpture.

Many antique photographic processes and most photoprintmaking procedures rely heavily on litho film as an intermediate step. These processes usually cannot accommodate middle tones, and the image must be produced using standard litho or halftone techniques.

Greatly enlarged, this halftone pattern shows the varying sized dots used to give the impression of continuous tone on high-contrast materials.

Halftones

A halftone is a litho film image that renders apparent continuous tone by converting shades of gray into varying sizes of black dots. The coarse screen used by newspapers can be seen with the unaided eye, but you need a magnifying glass to see the dots in the photographs reproduced in this book. Halftone dot patterns are normally produced by exposing litho film through a commercially manufactured halftone screen. These screens sell for several hundred dollars each and so are beyond the scope of this book.

A Kodak product called Autoscreen Ortho Film, unfortunately not generally available, combines the features of litho film and the halftone screen, producing halftone dots automatically when exposed and developed like litho film.

1. *This photograph was taken from a sailplane on fine-grain 120 film. The transfer to litho film raised the contrast and sharpness of the grain pattern.*

2. *The original litho positive (1) was contact printed on another piece of litho film to produce a negative. A small section of that negative was enlarged to show the tapestry of solid black dots.*

3. *The enlargement (2) was contact printed to produce another negative. Enlargement of the second negative produced this abstracted image.*

Light and Shadow Contrast

Light, of course, is the real medium of photography. If the light is not interesting in the original scene, it won't be interesting in the litho image. Light and shadow are the key elements in the description of the image on film. Hard, directional, contrasty light produces dark, hard-edged shadows. The darker the shadows, the more likely they are to become black spaces in the high-contrast rendition. Highlight areas will tend to block up and become white spaces in the final print. When shooting under these conditions, try to visualize the abstracting process that will take place during the conversion to high contrast. Darks become jet black; lights become paper white. The recorded description of silhouette and shadow edges will gain in graphic emphasis. As in any photograph, tonality is described on film by the combined effect of light, shade, and local color value. Any medium tone will drop into black, white, or a speckled granular area, depending on camera format and light and color conditions. Color value can be modified to a limited degree by filters on the camera. These are particularly useful in shooting green foliage, which has a tendency to turn black: a yellow-green filter will keep leaves light enough to render sufficient detail; infrared film is also useful for this application. Subjects that are basically black and white to begin with can produce startling graphic effects.

Combining Techniques

Litho film images can be readily combined with texture screens, as shown by this combination of a tone-line image of a tree with a homemade dot screen.

*1. **Litho film positive** enlarged from a camera negative.*

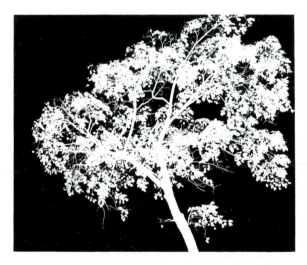

*2. **Litho film negative** made from the litho positive (1).*

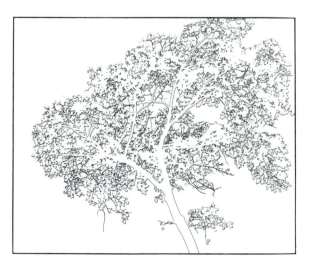

*3. **Tone-line positive** made by combining the litho positive (1) and negative (2).*

4. Texture screen made by spraying dense black ink on clear acetate.

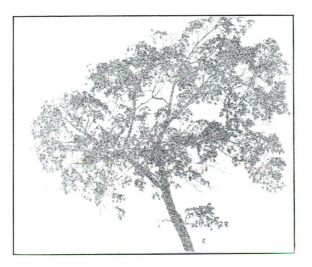

5. Intermediate step made by contact printing from a sandwich of the litho film negative (2) and the screen (4).

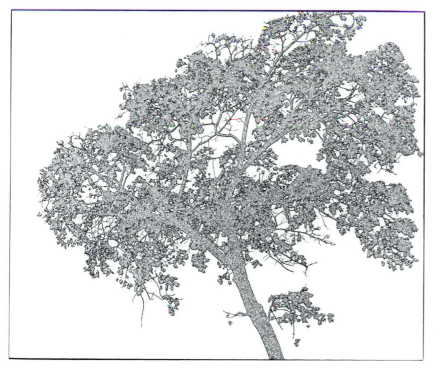

6. Final print contact printed from a sandwich of the negative of the screened tree (5) and the tone-line positive (3).

Considerations When Photographing

Camera Format

It is possible to expose litho film directly in the camera. Darkroom conversion from a continuous-tone negative is less difficult, however, and will also provide you with greater latitude for image interpretation.

If for some special reason you want to shoot litho film directly, it can be loaded into film holders for view cameras or purchased in 35mm size in 100 ft rolls (Kodalith 6556, Type 35mm) and bulk-loaded. When exposing in the camera, it is advisable to bracket five exposures at one-half-stop intervals. To avoid reciprocity failure problems, bracket using aperture instead of shutter speed. Exposure is very critical and must be perfect to record a usable image.

When shooting conventional film for intended transfer to litho film, the kind of camera you use makes a difference. The smaller the original negative, the less detail will be recorded. Formats of 35mm and smaller will produce a final image characteristically bold and graphic. As negative size is increased, there is a corresponding increase in image detail.

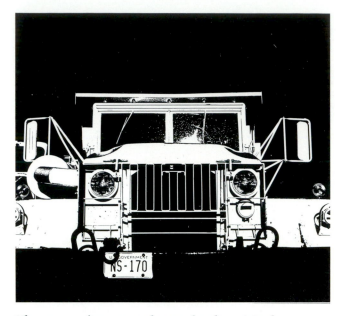

The camera format used to make the original negative can have a significant effect on the quality of the final image. The photograph was taken on 120 film and enlarged directly to its final size. The details and traces of tone are represented by granular areas.

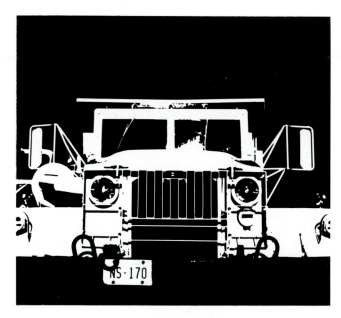

For purposes of comparison, this print was made from a 16mm negative made at the same time and printed on litho film in the same manner. The smaller-format film increases the apparent abstraction of the subject, a quality often desirable for a graphic effect.

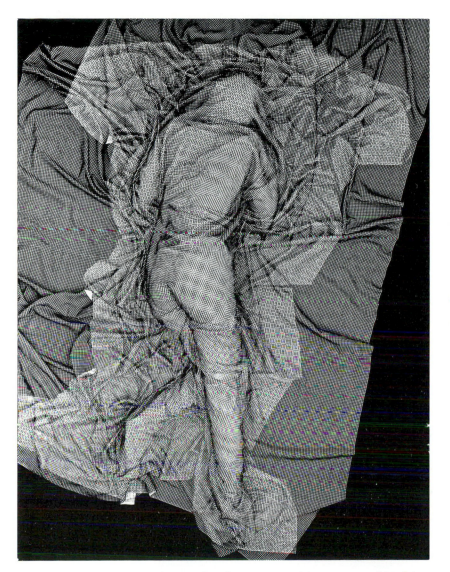

Shooting for Litho Printing

So far, discussion of technique has centered around the application of darkroom procedure to existing negatives, but it is likely that the best imagery will be produced by shooting specifically for the particular process involved. The image qualities and processes can be fine-tuned to complement each other.

Whether you are setting up shots or searching for interesting visual material with your camera, it is useful to have prior darkroom experience with this film. An afternoon of experimentation with litho materials and some old negatives will be a worthwhile initial experience. Try several techniques and apply them to a variety of imagery. Include contrasty and softly lit subject matter, and fuzzy as well as sharp negatives. Try working in large and small formats. Each of these variations will affect the character of the images produced later.

An overhead camera position was used in this multiple exposure made in the camera. The model was draped with patterned fabric for the first exposure. With the model maintaining the pose, the fabric was rearranged and a second exposure was made without advancing the film. New patterns defining the form of the figure were created wherever the patterns overlapped.

Development for Detail

Fine Line Developer

Fine Line Developer is a special product man-
ufactured by Eastman Kodak to be used with
standard litho film. Its use will help to create,
as in the illustration on p. 141, a high-contrast
film image with the finest possible detail and
grain. For best results, place the litho sheet
film in a flat-bottomed darkroom tray con-
taining Fine Line Developer mixed as directed.
Agitate the film very gently for the first 45 sec
and then leave the tray absolutely motionless
for the remaining 2 min of development. The
effect is quite subtle. A similar result can be
obtained by diluting the standard developer
with half its volume of water, or by adding
slightly more of the standard *B* solution and
letting the working solution oxidize in the
tray for an hour before use. The fine-grain
examples in this chapter were produced using
diluted standard developer.

*The treatment of this image was as described
on p. 141, for maximum preservation of de-
tail. Taken in soft, diffuse light with full ex-
posure of the original negative, it was enlarged
to final size on the first intermediate film
sheet.*

*This is the result of developing the litho film
in fine-line developer, in addition to the
treatment described above.*

Three different original negatives were used to complete this complex assembled image. The room is a cut-paper miniature less than 20 cm tall. The sky and the real-life model were added using the masking technique described on pp. 124–127.

Simplicity vs. Detail

The form of the model's body and clothing are described solely by the patterns of the fabric. There are no gray tones, shadows, or textures. The pattern alone bears the message of the image. This simplification of an original photograph is the most immediately apparent use for litho film and high-contrast printing.

Maximum Simplification for Graphic Effect

1. Use a small-format camera and fast film.

2. Select objects that are black and white or dark and light to begin with.

3. Look for hard directional light, producing sharp, dark shadows or throwing the subject into silhouette.

4. Slightly underexpose and overdevelop original continuous-tone film.

5. Use regular formula litho developer.

6. Convert the image to litho film by the direct contact process. Enlargement on paper should be the last step.

The form of the fruit is described by texture, subtle tonality, and shadow. The litho film, through careful processing, has preserved most of the detail in the original camera negative, but the enhanced sharpness and grain give this print a unique quality. The tones are ac- *tually small black dots producing the illusion of grays. The sense of infinitesimal detail heightens the illusion of realism in an effect totally opposite to that of the illustration on the facing page.*

Maximum Detail for Realistic Effect

1. Use a large-format camera and medium- or slow-speed film.

2. Select objects of medium color value; filter if necessary.

3. Look for soft diffused light, soft light shadows.

4. Expose original continuous-tone film normally, and develop for normal or slightly less than normal time.

5. Develop the litho film positive to preserve the fine grain. (See Development for Detail, p. 138.)

6. Make the largest possible internegatives. First transfer the image to litho film, by enlargement; then contact print to make the final litho negative. It is possible to increase grain fineness and detail further by making the first enlargement on final-size, continuous-tone sheet film. The sheet film is then contact printed to produce the final litho negative.

LIQUID EMULSION
Gail Rubini

Like most photographers, I began my photographic work with light-sensitive paper. As a medium to convey an image, paper offers a great many advantages. It is flexible, resistant to aging, and inexpensive. I became interested in replacing the ordinary photographic surface after realizing that the illusion of form and space can be extended by altering the normally flat photographic surface into a three-dimensional one.

This interest led me to the use of Liquid Light, a commercially produced emulsion of photosensitive silver halides and almost transparent gelatin. Although it is virtually the same as the emulsion on ordinary photographic paper, the fact that it is supplied in liquid form allows me the freedom to use a variety of support surfaces, including glass, fabric, wood, plastic, and plaster, in my photographic sculpture.

Paper imposes a rigid, two-dimensional constraint on a photographic image; other supports offer an opportunity for the photographer to manipulate the surface form and depth as well as the photographic image itself. My early experiments were collages of normal photographic prints onto sculptural pieces, a process that blended the illusion of the form and the photographic sense of reality. After discovering the liquid emulsions, I found I could eliminate the paper surface entirely by transferring the image directly onto the sculptural surface.

The marriage of form and image inherent in photographic sculpture created the need for me, as a photographer, to explore the complexities of sculptural form. In my early work, I began with a photographic image and searched until I found a ready-made object that complemented the image. For example, I printed a picture of a desk on the wall of an empty room and a photograph of a party on a glass, plate, and spoon of a table setting.

As my work progressed, I found that not only did the shape of the surface affect the photographic image, the surface itself became an integral part of the image. Since the Liquid Light emulsion is virtually transparent, the image embodies the color, shape, and texture of the underlying surface. I sometimes use this characteristic to inject color and texture into the photographic image. I have used wood, plaster, and fabric in this way, although recently I have begun to accentuate the transparency of the process. By transferring the negatives onto glass and other transparent surfaces, I can create a marriage of form and image, which are at once complementary, yet independent.

Over the years I have used various media to present my photographic images. I once spent a great deal of effort in developing a homemade emulsion; I now use a commercial product. I once used ready-made objects as sculptural forms; I now use my own glass and plastic sculptures. Throughout this evolution, my experiments with the integration of photographic reality with sculptural form have remained very satisfying. My photographic sculpture works toward a harmonious symbiosis of form and image. As my sculptural forms become more abstract and elusive, the photographic image brings them back to my reality.

Liquid Light

In 1969 I began searching for some kind of liquid emulsion by mixing my own emulsion from formulas found in old photographic journals. This method proved inconsistent and bothersome, since many of the chemicals were difficult or impossible to locate. In 1970 I began almost exclusively to use Liquid Light, a commercially available liquid emulsion produced by the Rockland Colloid Company. Liquid Light is a medium-speed emulsion that works under normal photographic conditions. It is available in four sizes: half-pint, pint, quart, and gallon. Liquid Light is packaged in light-tight plastic containers. It should be stored in a cool place or refrigerator for maximum shelf life. Freezing may alter the viscosity of the emulsion and is not recommended.

Liquid Light is extremely sensitive to age. When freshly made, it is less sensitive to light and lacks its maximum density and contrast. As it ages, it acquires the desirable characteristics. Eventually, the emulsion will fog or turn black. When purchasing Liquid Light, make sure it is fresh and try to use the emulsion within a month after purchase. The shelf life is dependent upon temperature, as heat accelerates the aging characteristics. Shelf life with refrigerated storage is claimed to be six months.

Information about Liquid Light is available from the manufacturer:

Rockland Colloid Corp.
599 River Road
Piermont, NY 10968
(914) 359-5559

Handling the Emulsion

Liquid Light is sensitive only to blue light and can therefore be handled under almost any safelight in a conventional darkroom. The emulsion contains phenol as a preservative, and its vapors can be harmful; adequate ventilation in the darkroom is essential. When doing large-size or high-volume work with Liquid Light or when spraying the emulsion, wear a respirator suitable for organic vapors.

The emulsion is solid at room temperature and must be warmed to become a usable liquid. Place the bottle in a container of water at 40°C and it will quickly melt. After a few minutes, you can pour off the portion you need (liquefying the entire contents is not necessary or recommended). Remember that the emulsion is light-sensitive, and all handling must be done under safelights. Try not to allow the emulsion itself to become hot. It should not be heated above lukewarm (35°–40° C), or it will develop a fog. Do not shake the bottle, as bubbles will form that will interfere with the coating. Pour the desired amount of emulsion into a container of glass, plastic, or stainless steel. Do not use utensils or tools of copper, brass, bronze, or iron, as they will react with the silver in the emulsion. Be careful to wipe the top of the container free of any drips of emulsion that could be exposed during storage: a drop of fogged emulsion can fog the remaining contents.

The emulsion will quickly melt into a usable liquid at 40° C.

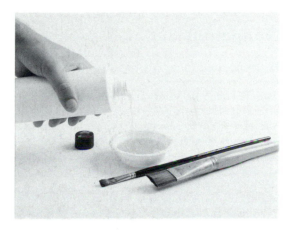

Remember to pour, coat, dry, and expose the liquid emulsion under the proper safelight.

A Test for Fogging

After purchase of Liquid Light, or before use if it has been stored for a long time since purchase, a test for fogging is necessary. Place a few drops of emulsion on an index card or piece of paper and allow the emulsion to dry until sticky. The emulsion is easiest to work with when it is thoroughly dry, but it can be processed when still tacky. Develop the paper in your normal paper developer, without exposing, for the minimum time recommended by the developer manufacturer. I use 1 min in Kodak Dektol 1:2. Without rinsing, place the paper in a hardening fixer for 5 min. Turn on the lights and inspect for gray areas. If the emulsion is not completely clear and transparent, mix the antifog supplied with the emulsion according to the directions, and add it to the developer. After mixing, the antifogging solution should be stored out of the light at room temperature.

Preparing the Piece

The preliminary preparation of the piece, or subcoating, is the most important step in the process. Care and practice may be needed before good results can be achieved. There are three types of surface that require special preparation: (1) one that is nonporous, such as glass, china, or enamelware; (2) one that is highly porous or crumbly, such as plaster or unfired ceramic; (3) one that chemically affects the emulsion, such as some metals or compounds containing sulfur.

Nonporous Surfaces

For nonporous materials like fired ceramic, china, enamelware, glass, rocks, or shells, the supplied subbing solution should be applied before actual coating with the emulsion. Before any subbing is applied, the surface should be cleaned thoroughly by scrubbing with a hot solution of sodium carbonate, also known as sal soda, soda ash, and washing soda. Objects can also be washed in an automatic dishwasher.

Prepare the subbing solution ahead of time according to the supplied directions. Just before use, mix equal quantities of the two stock solutions and flow on, by dipping or soaking; then drain off. Dry at least 1 hour before applying the emulsion. It is best to let the subbing dry completely and repeat the coating process at least once. Store the subbing solutions in a cool place, and warm the tan crystal solution before each use.

Porous, Metal, and Plastic Surfaces

For highly porous materials, such as brick, plaster, unfired ceramic, and concrete, or for metals (except aluminum), plastics, paint, or varnish, apply a thin coat of polyurethane finish diluted with an equal part of naphtha, or benzene.

Use a polyurethane finish whose label says it contains oil or mineral spirits, not one that requires a special thinner. Polyurethane and naphtha are available at most paint and hardware stores. If polyurethane is not available, a phenolic or bakelite varnish can be used, diluted 1:1 with naphtha. Once again, flow on the solution by either dipping or soaking and allow the piece to drain. Let the subbing dry at least 12 hours before applying Liquid Light. It should be noted that this subbing has a permanent slightly yellowish tint.

Other Surfaces

You can apply the emulsion to materials such as clean unprimed canvas or cloth without preparation. Test a portion first to make sure that no chemical contamination will affect the emulsion. Unless the emulsion is sealed after processing, it will dissolve in warm water. Sealing will render the cloth relatively inflexible, so Liquid Light is not a good medium for printing on clothing.

Usually no surface preparation is necessary for paper or wood, except for laminates such as interior plywood or laminated cardboard containing water-soluble glue. Such glues will fog the emulsion and should be isolated with a heavy preparatory coat of polyurethane or phenolic varnish.

The emulsion will adhere to anodized, unsealed aluminum without surface preparation. For materials such as leather and rubber no preparation is needed if oil and wax are removed. To make the emulsion more flexible, add one teaspoon of glycerine per quart of emulsion before applying.

To primed canvas apply a thinned coat of gesso or dilute flat wall paint and allow to dry at least 24 hours. Apply the emulsion and allow it to dry thoroughly in low humidity conditions before processing. Liquid Light will not adhere directly to preprimed canvas.

In this sculptural piece, as in the piece shown at the beginning of this chapter, the author has applied the image, using liquid emulsion, on glass objects of her own making. The object's shape in this case mimics the characteristic curl of the film printed on it.

Applying the Emulsion

Flat Surfaces

To coat glass, metal, and other rigid, small, flat surfaces, the easiest way is to pour a surplus of the emulsion onto the surface and spread it quickly with a fingertip, tilting the surface so that the emulsion covers completely. Move carefully to avoid creating air bubbles. Without allowing the emulsion to harden, pour the excess emulsion off one corner through a funnel back into the bottle. Next, set the emulsion-coated object down flat, with a slight jar to break the air bubbles that may have occurred. Bubbles can also be broken by exhaling gently onto the surface; be careful not to blow hard enough to make the emulsion uneven. Allow the object to stay flat in a dark place for 10 to 20 min. It will dry best with ample circulation of fresh air, and drying may be hastened with cool air from a fan. Exposure and processing should begin after the object is completely dry.

For objects that are large and flat, like stretched canvas, follow the same basic procedure, but spread the emulsion with a coarse brush, such as a wallpaper brush, so that the emulsion will fill in behind the bristles and not leave streaks. Alternately, you can use a fine-bristled brush and apply two or more coats. When applying extra coats of emulsion, you should allow the first coat to stiffen and become almost dry before the next coat is applied. Apply the second at right angles to the first. Allow it to dry thoroughly before processing.

It is always a good idea to run through the process on a small-scale piece before trying it on a larger one. If Liquid Light seems to be drying before you can cover the entire piece, it can be thinned by adding up to 20% of its volume of warm water to retard the drying time. If you thin the emulsion, you may need additional coatings.

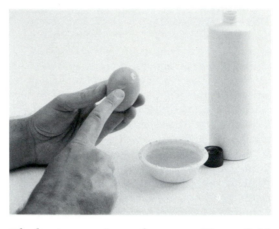

The least expensive and most readily available applicator is shown here coating the emulsion on an egg.

A high-quality artists' brush will serve to coat flat surfaces evenly.

Irregular Surfaces

For irregular surfaces, such as rocks, apply Liquid Light by dipping if possible. Drain the piece and wait until the emulsion dries or becomes sticky before setting it upright. Pieces should be dipped at least twice and then dried. For larger irregular surfaces, the emulsion can be painted on, using more than one coat, or sprayed to ensure complete coverage.

For spraying, thin the emulsion by mixing 500ml of methyl alcohol (methanol) with 50ml of butyl alcohol and adding 50ml of water and 5ml of formaldehyde. Stir the mixture into 1 liter of Liquid Light just before use. Wear an organic vapor respirator, and spray in a well-ventilated area. To spray on small areas, you can use a refillable aerosol like Pre-Val, available in hardware stores. For larger areas, use a compressor-type spray gun with an external mix nozzle to prevent clogging. If the spray gun contains aluminum parts, wash them very thoroughly with hot water after use, to prevent corrosion. If your spray gun has a brass nozzle, experimentation will determine if it will contaminate the emulsion. If so, replace it with a stainless steel tip.

Remember, all coating and drying steps must be carried out under safelights. Processing the piece is easiest when the emulsion is completely dry. If the piece has to dry for several hours, it is best to dry it in a well-ventilated, light-tight area. I made a large light-tight box, including a fan to circulate air, so that my darkroom would be usable while I waited for the emulsion to dry. The drying area should remain at a constant cool temperature.

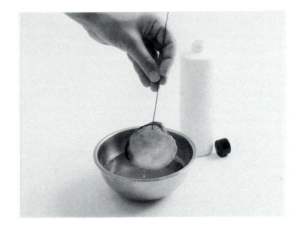

Small, irregularly shaped objects, such as this clam shell, may be coated by dipping.

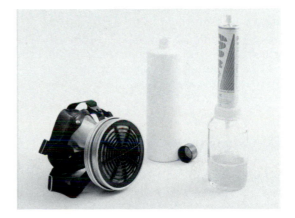

Do-it-yourself sprayers can be used to coat large objects. Be sure to wear an organic vapor respirator, such as the one on the left.

Processing

All steps in processing are best done by immersion with little agitation of the liquids. It is best to keep all temperatures of the process as cool as possible without affecting the development time.

The key to success when using Liquid Light is patience. If you use an incorrect exposure or don't process properly, you can remove the emulsion with hot water and start again. It may take several tries before you can coordinate the subbing and the emulsion into the perfect mixture.

Exposure

The piece should be exposed with an enlarger as though it were ordinary photographic paper. Avoid very dense negatives that require a long exposure time and those requiring significant burning and dodging. A test strip made by coating the emulsion on an index card will help you determine the correct exposure, or you can make a better test strip by using the same material as the piece itself.

Development

For development of the dry emulsion on the piece, you can use any normal photographic developer. Use an active developer such as Kodak Dektol diluted 1:2 for high contrast and line work, and a soft-acting developer such as Kodak Selectol diluted 1:1 for continuous-tone work. Add the antifoggant if needed. Do not overdevelop. Allow for a total development time approximately three times as long as it takes for the image to appear. This will be 1 min in Dektol and 1½ min in Selectol. The developer may be applied with a very soft natural sponge, by submersion in a tray, or if necessary, by spray. The developer temperature is critical: it should not exceed 21° C, or the emulsion will become soft and may melt off the surface.

Fixing

Always neutralize the developer with an acid stop bath for at least 30 sec. Do not use an indicator stop bath, as it may stain the emulsion. Ordinary white vinegar diluted 1:1 makes a good stop bath for Liquid Light. Keep the temperature of the stop bath below 21° C also. Use a hardening fixer or rapid fixer with a hardener added. Fix the piece for at least twice as long as is necessary for the emulsion to clear or become transparent. During the fixing, the subsurface will gradually emerge through the transparency of the emulsion, and will alter the appearance of the image.

For large surfaces, the fixer may be applied liberally with a sponge. You should fix for at least 5 min to allow the hardener to have effect. If the emulsion does not clear, even after the proper fixing time, the emulsion has been applied too thickly. An emulsion that is white or translucent after fixing will turn brown in white light. The emulsion is properly fixed when it is completely clear.

*Chicago-based artist **Conrad Gleber** here allows the brushstrokes from applying the liquid emulsion to the paper to become an integral part of the image.*

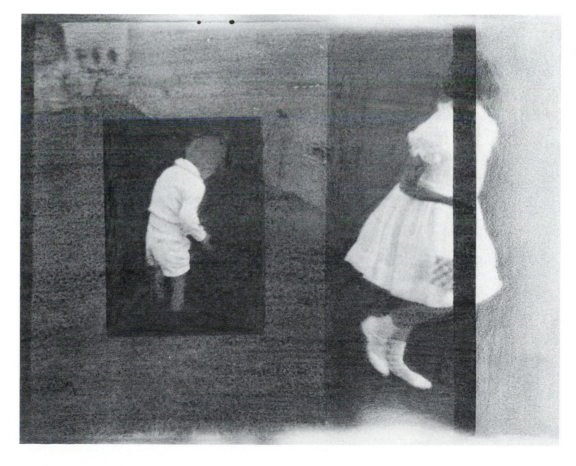

Finishing

Washing

Wash the piece as you would an ordinary print, preferably using a hypo clearing agent also. Prints on nonporous surfaces, such as china, will wash in 10 to 15 min, whereas prints on porous materials, like wood, should be washed gently for at least a half hour.

Drying

Once the piece is processed it should be dried in a clean area. When dry, the emulsion is tough and hard as long as it is kept dry. Eventually it will become brittle. For complete protection, moisture can be excluded by coating the emulsion with dilute polyurethane varnish, either glossy or semigloss.

Recoating

The piece can be coated again if a multiple exposure is desired. No additional subcoating is needed, but the first emulsion should be properly washed and dried before recoating. If a piece turns out to be unsatisfactory, you can remove Liquid Light with hot water. Be sure the piece is thoroughly dry before beginning the process again.

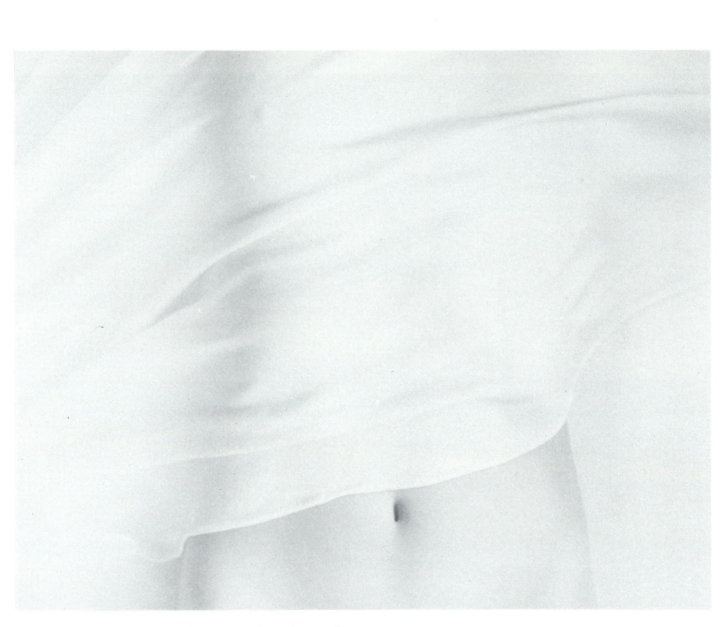

*By applying liquid emulsion to large-size etching paper, photographer **Morimoto** complements the softness and subtlety of his imagery with the delicate surface of a fine paper.*

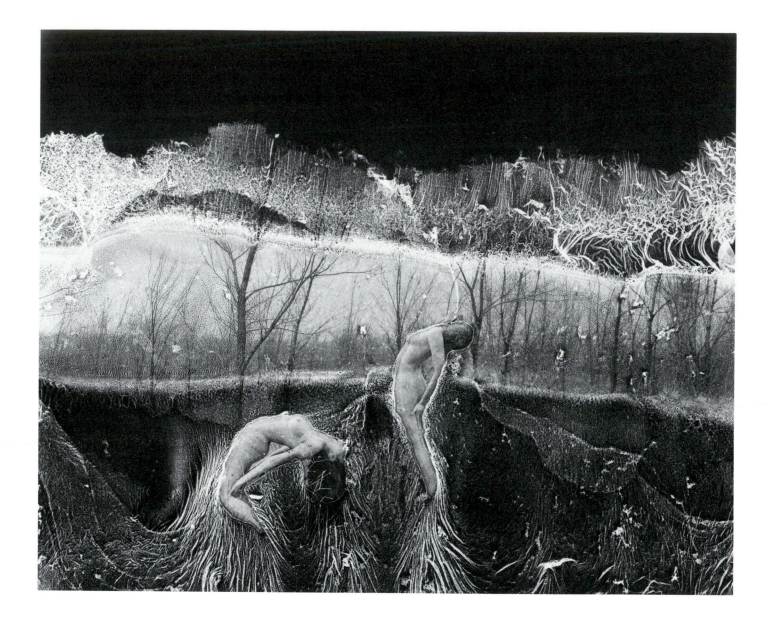

RETICULATION
Michael Teres

Reticulation is commonly viewed as a processing error caused by extreme changes in the temperature of film developing solutions. The result is a pattern or texture, a crinkling of the gelatin emulsion, and a migration of the silver particles, which clump together into varying patterns.

Reticulation need not always be a mistake. In fact, it can be used as a deliberate technique to create textures and manually distort the photographic image. It is one means of shifting from the traditional "taking" of photographs to the "making" of images through post-visualization. You can select individual frames from normally processed film and determine the type and extent of reticulation desired. The film may even be several years old. You can use a normally developed negative and perform a series of distortions upon it, producing a variety of effects in the final print.

As the negative reticulates — as it begins to dissolve — an entirely new range of images begins to appear. There is the excitement of discovery in working with the dissolving images. As the original photographic reality begins to disappear, a new image with its own reality emerges. The dissolution can be halted and fixed into a picture.

As the emulsion dissolves, the manipulation of some of the areas on the negative distorts the traditional ground line and disturbs the normal orientation of figures in space. The resulting illusion is of a free-floating, other-worldly space. Rather than the commonly accepted reality, the resulting image implies additional dimensions of reality. It hints at philosophic concerns and points to a mythic reality.

Traditionally, a photograph stops time, interrupting the flux of visual sensations and fixing a moment into an image. It dematerializes the three-dimensional world and re-creates it as a thin emulsion. My images are moments of transition in time. Through reticulation, they move from the static scene captured by the camera through a fluid state freed from time and arrive evolved into something new, the normal time-space relationship having been altered in the process.

Reticulation is the photographic process that best expresses my image-making concerns. The personalization of a process is a vehicle of expressive content, often a content that cannot be articulated without the medium at hand. Through reticulation I can arrest the image that before I could only sense.

What Is Reticulation?

The process of reticulation is somewhat unpredictable. In fact, totally different results may occur on each negative from the same roll of film. Often this unpredictability is caused by variables that cannot be controlled: manufacturer's changes in film emulsions, minor variations in the strength and activity of the developer and fixer, contrast and brightness range of the subject matter, temperature loss of the reticulation solution or variations in the individual negatives used. Despite the variables and the unpredictability of the process, several stages occur often enough to become categories: simple reticulation, radical reticulation, veiling, and differential reticulation. Each is an extension of the same basic process — simple becomes radical, radical can become veiling, and differential can be any of the three.

All the images and information presented here result from the use of Kodak Tri-X 120 roll film. Although all manufacturers incorporate hardeners into their films to prevent reticulation, the process will work with most films. The film may even have been processed several years ago. The older the film, however, the harder the surface and the more limited the potential for variations of reticulation patterns. Film type, developer used, hardening or nonhardening fixer, the temperature and concentration of the reticulation solution, and the length of time between film development and reticulation attempts will influence the end result.

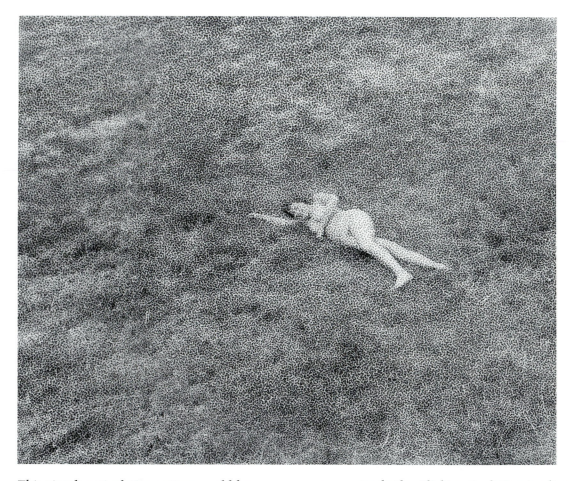

This simple reticulation pattern could have been caused by temperature fluctuations in processing baths. Slight reticulation is often mistaken for graininess.

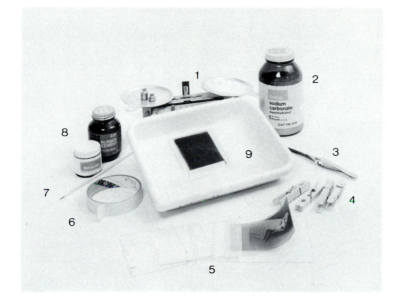

Materials necessary for reticulation.

The Materials

Materials needed for reticulation, beyond those necessary to process your film, include:

1. Gram balance or scale

2. Sodium carbonate, available in most photo stores

3. Tweezers or small tongs

4. Clothespins

5. Small sheets of thin Plexiglas or glass

6. Masking tape

7. Spotting or #0000 artists' brush

8. Maskoid or rubber cement

9. Small plastic darkroom tray

Immerse the negative in hot sodium carbonate solution to begin reticulation.

Simple Reticulation

Simple reticulation is an overall pattern in which the film emulsion stays intact; it is the reticulation often referred to and illustrated as a processing fault. The procedure begins with a fully developed, fixed, washed, and dried negative.

Mix the reticulation solution in a small tray: 30g of sodium carbonate in 500ml of water at 60°–65° C. I use an electric coffee pot as a source of constant-temperature hot water. The useful range of temperatures for the sodium carbonate bath is from 40° C to about 70° C. Lower temperatures take long periods of time; higher temperatures deform the plastic film base, which prevents the negative from staying flat during printing.

Attach the negatives, singly or in strips, to a piece of thin Plexiglas at least 2cm larger than the negative in both dimensions. This is to facilitate immersing the negative in the sodium carbonate solution. Use masking tape on one long edge only. Work with the largest film size that you can. Negatives 6x7 cm or 6x6 cm (2¼″ square) are large enough to allow visual appraisal of the work in progress. If you are working with 35mm film, cover both sets of sprocket holes with masking tape to prevent the reticulation pattern from becoming too active in the area in which the holes are punched.

Immerse the film in the hot sodium carbonate solution and watch as the liquid almost immediately begins to cloud. A slime will appear on the surface of the film and rise to the surface of the solution. This is a protective coating on the emulsion. In most cases the loss of this coating is inconsequential, but with some films its removal produces a visible density difference and texture in the printing.

With films that have not been fixed in an acid hardening fixer, simple reticulation can be

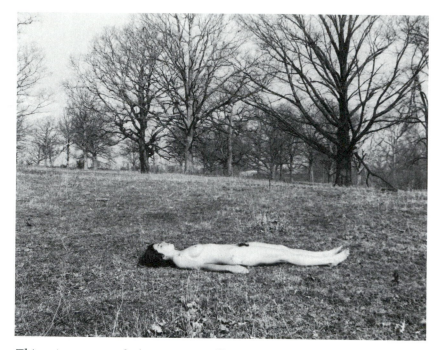

This print was made from a normally processed 120 negative.

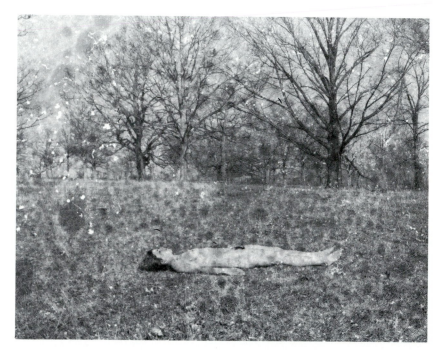

Upon immersion in the sodium carbonate solution, the protective gelatin layer dissolves.

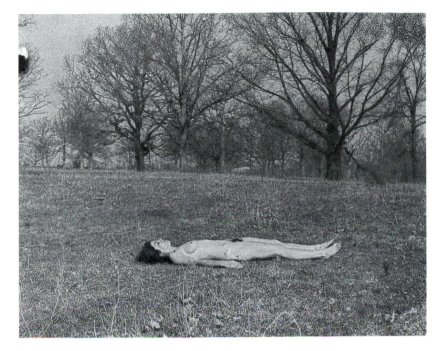

The earliest stages of simple reticulation show a slight texture.

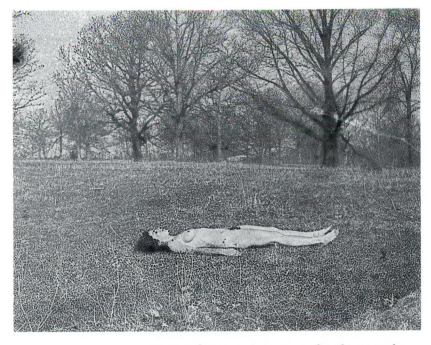

Texture becomes pattern as the alteration becomes more apparent.

achieved by soaking the film in plain water at about 65 ° C. Since there is no danger of radical reticulation, the film can be left in the water until it cools, then hung up to dry. The resulting pattern is much finer than would occur using a sodium carbonate solution.

As the size of the reticulation pattern is ordinarily about the same for all films, it is important to establish your own limitations. Reticulated 35mm film may be enlarged only so much before the overall pattern becomes overwhelming, whereas 4x5 film may need to be greatly enlarged before the pattern becomes visually effective.

Not all films react to the sodium carbonate solution in the same way, and not all films reticulate readily. Kodalith will not reticulate, nor will most copying films, such as direct duplicating film. I have had most success using Kodak Tri-X, although it is possible to use Plus-X and Panatomic-X. There are some problems with these alternates. In some cases, the rapid dissolution of the film as it begins to reticulate thins the density or quantity of silver in the emulsion until it becomes difficult to print. Tri-X seems to resist this dissolution best.

Leave the negative in the solution from five to twenty minutes, depending on the magnitude of the desired pattern. If you want a simple pattern that permeates the film as a very fine texture, five minutes will suffice. If the desired pattern is larger or more exaggerated, up to twenty minutes in the sodium carbonate solution may be necessary.

Rinse off the negative in cold water when you have achieved a satisfactory reticulation pattern and hang it up to dry.

It is helpful to make your measurements of chemistry by weight instead of volume, and to use identical developer, fixer, and processing procedure for all of your film in order to have more consistent results in spite of the variables and unpredictability.

Radical Reticulation

Radical reticulation results when the pattern begun as simple reticulation becomes so large that areas begin to dissolve and there is a physical breakdown of the emulsion. The image then becomes liquefied and movable, and part of the emulsion may detach or dissolve.

Use a weaker concentration of sodium carbonate for a radical reticulation. A solution of 15g of sodium carbonate in 500ml of hot water works best. After two minutes, the film will begin to soften and lie flat, and the protective gelatin coating will begin to disintegrate and float away. Gradually, the emulsion itself will begin to melt and dissolve. This second softening or blistering of the emulsion is the critical point. If your timing is wrong, even with supports, the image will be lost. The support piece of glass or plastic slightly larger than the film is useful and sometimes necessary. When the emulsion begins to liquefy, it can easily slip off the base because of pressure from the surface tension of the solution. The glass acts as a rigid backing and allows you to break the liquid with its edge so that the film can stay on its support.

Time and temperature are the controlling factors. In a very weak solution of 7.5g of sodium carbonate to 500ml of water, Tri-X Pan Professional will begin to dissolve and flow in approximately five to ten minutes, whereas ordinary Tri-X will have achieved only a moderate to fine textural pattern in the same period of time. The ordinary Tri-X takes about twenty minutes to reach the point at which it will flow and dissolve.

Radical reticulation appears as a breakdown of the emulsion.

The pattern of radical reticulation continues to enlarge.

The original image gradually becomes unrecognizable.

Abstracted by pattern, the image space becomes two-dimensional.

The temperature of the sodium carbonate solution should begin at 65° C. Once the temperature goes below 35° C, the time necessary to achieve a reticulation pattern is so great that it is preferable to heat the solution, mix up a fresh batch, or immerse the material in a plain hot water bath.

Some of the film reticulated in my experiments has been as old as three years, but because film hardens as it ages, the process takes longer and the results are quite unpredictable. In some cases, no reticulation will occur, sometimes only a trace, sometimes a full reticulation pattern, sometimes the emulsion will dissolve completely. If you are lucky, a radical reticulation will occur. Some of the older negatives I have used were soaked for as long as two weeks before any satisfactory results were achieved. Despite the length of time necessary to soften the emulsion, there is a critical period of time, usually only a few minutes, during which the film must be removed from the sodium carbonate solution or the emulsion will slide off the base. This spontaneous stripping happens more rapidly to newly developed film, often occurring within the first five minutes in the solution.

Once the emulsion reaches the flow point it is quite pliable and the image can be moved around with a fingertip or its movement directed by tilting the Plexiglas to which the film is attached. As in simple reticulation, the film development time, kind of developer, density, and age of the film, and whether a hardening fixing bath was used will affect the film's reaction.

Veiling

Veiling results from the physical breakdown of the emulsion. As the film continues to disintegrate in radical reticulation, the individual pockets of clear area within the textures begin to open and the original image breaks down. The emulsion begins to dissolve and large areas undergo a radical change.

Hold the film in a vertical position to cause areas that have swollen and filled with liquid to rupture. The veiling pattern will appear as the emulsion begins to stretch out. The emulsion remains attached to the film base, with portions of the emulsion folded over onto itself, creating greater image buildup and density. This will often result in veil-like or net-like patterns.

The veiling results when the emulsion begins to lift or float off the base and is physically folded over onto itself and allowed to float on the film base until dried onto it and solidified. The film begins to soften earliest in the clear areas where there is no silver buildup. Thus, the edges soften first.

Push the stripped emulsion from the edges toward the center. Be very gentle. This procedure allows the emulsion to remain attached in the center while free to frill or flap up and down at the outer edge. The film is so resilient that you can stretch the image and it will usually return to the original form. Occasionally it becomes necessary to cut or break the emulsion image if it stays in its distended form.

Veiling is begun by the liquefaction of the film. Your clue to the onset of liquefaction will be a series of soft, undulating waves or large blisters on the surface. If the film is lifted out of the sodium carbonate solution at this point, it can be held vertically until the emulsion runs or begins to slide. After the film begins to dissolve and the areas filled

The image is almost completely dissolved into pattern.

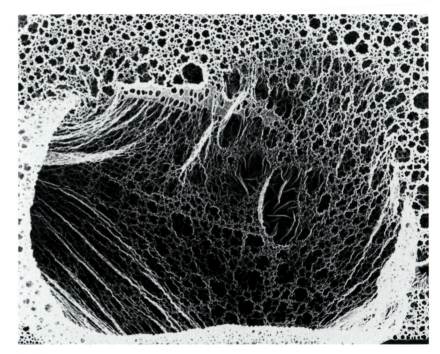

Veiling occurs as the emulsion begins to slide off the film.

162

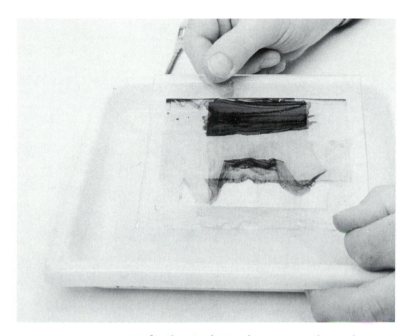

Radical reticulation becomes veiling when areas of the emulsion begin to fold over one another.

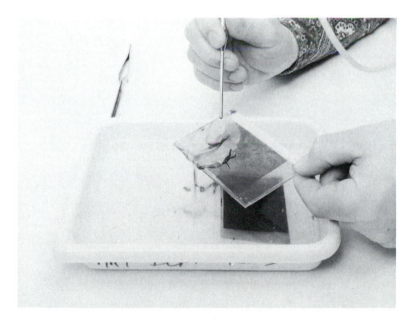

Directing a thin stream of water at the negative with this hose attachment allows selective removal of unwanted areas.

with liquid have begun to rupture as the emulsion stretches out, the film can be replaced in the solution so that it will undercut and open up much more quickly.

Push the emulsion about with a finger or brush. At this point it can be physically manipulated. I occasionally use a faucet attachment similar to a Water-Pik tip to direct a thin stream of water at the negative to wash off softened parts of the emulsion.

As with radical reticulation, the film should be taped emulsion side up on Plexiglas. While the emulsion is in a liquid state, concentric or parallel linear patterns can be created by holding the film vertically or twisting it about as the emulsion flows.

The back of the film will also melt, producing some linear effects or visible density differences in the final print. When folding over or allowing the emulsion to sag, density differences are built up which may necessitate considerable burning or dodging of various parts of the image during printing.

Take extreme care to prevent dust and dirt from coming in contact with the wet film. The emulsion is particularly susceptible to dust in this state, and it is impossible to remove. Any dust adhering to the negatives at this point will cause problems in spotting the image, because the dust spot will never have the overall texture of the rest of the image, even if the spotting dye matches the tone exactly.

Hang the film to dry with a clothespin at each corner. This will help the film to dry flat, although some film will still be quite curly or distorted, particularly larger pieces of 120 size film. It may be necessary to print warped negatives in a glass negative carrier.

Differential Reticulation

Differential reticulation makes use of a resist material to protect areas of the emulsion so that part of the image remains intact and unreticulated. The film is masked with resist while dry, and then used with simple, radical, or veiling-pattern reticulation procedures.

Coat the emulsion side of the film with photographic Maskoid using a very small spotting brush. The resist should be applied directly on the emulsion. Photographic Maskoid is a red or black liquid similar to thin rubber cement, and is available in art supply stores. It allows you to coat areas where you wish little or no reticulation to occur. Rubber cement can be used, but it is difficult to see. The resist is not soluble in the sodium carbonate solution, but there may be some undercutting of this protective coating depending on the duration of immersion.

Recoating the film with the resist will allow a variety of patterns in a single image. Once the film has reticulated, even after thorough drying, it will rapidly resume its liquefied state upon immersion in plain hot water. It is possible to halt the reticulation process at any time, dry the film, and recoat it with a resist in order to retain desirable areas and remove or further reticulate the rest. In this way you can protect the original image and parts of the reticulated image and remove unwanted areas. This offers more possibilities in controlling the kinds of patterns and textures as well as alterations of the physical surface. Any part of it may be removed or left intact.

Remove the resist material itself by lifting it off with masking tape after the emulsion is thoroughly dry. Any areas that remain attached can be removed by applying pressure with your finger or by running a stream of cold water directly onto the surface of the film. The resist is designed to repel any liquids and should not be affected by additional soaking. It is also tough enough to withstand manipulation by slight pressure for short periods of time.

Agitation should be avoided. With the exception of the turbulence caused by removing the film and Plexiglas from the tray, there should be very little. If an air bubble gets

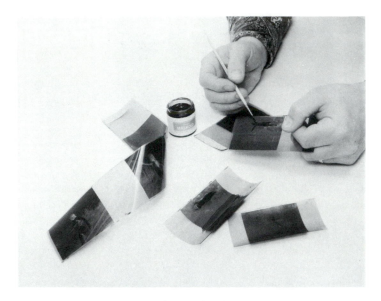

Areas to remain unreticulated should be carefully masked while dry.

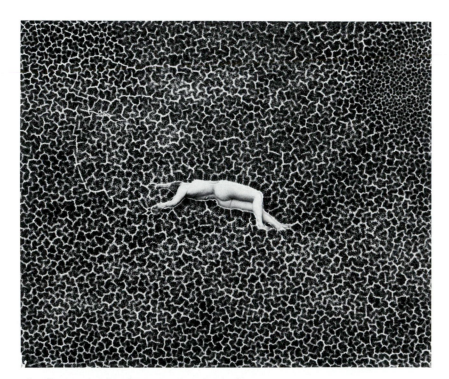

The figure amidst this pattern of simple reticulation was protected from alteration by masking.

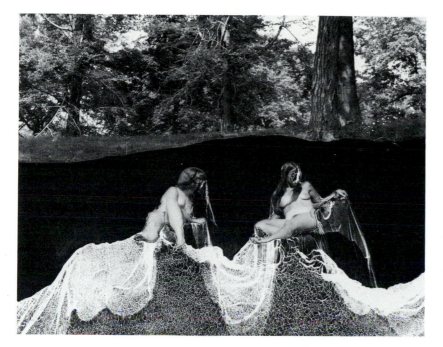

The upper background and parts of the figures were protected with Maskoid throughout the process. The lower foreground shows veiling; the emulsion from the black area was removed entirely with a stream of water.

trapped between the film and the Plexiglas, lift the film with a small piece of plastic or a stirring rod to allow the bubble to free itself from the base side of the film so that the film lies flat. It is sometimes helpful to pick up the tray and tilt it so that the liquid level is high enough to cover any high spot that may emerge as the film begins to swell and distort.

Remove the film while the emulsion is still fluid. The emulsion, once it begins to flow, will remain slightly liquefied and continue to dissolve even after it is removed from the sodium carbonate solution.

Dry the film while it is still attached to the Plexiglas. After it has dried it will be covered with white crystals.

Wash the surface of the film with cold water. The cold water reduces the amount of crystallized sodium carbonate on the film surface after it has dried. It may be necessary to repeat this cold water washing three or four times to remove all of the crystallization. In some cases, the crystal pattern is quite exquisite and you may choose to print through it. Exposure time increases considerably for a negative with a crystal pattern on it.

The sodium carbonate solution does not become exhausted with use, although it begins to get dirty as the gelatin dissolves into the solution. When it cools it can be filtered and reheated, but this is a needless economy. It is better to discard the dirty solution and mix up a new batch.

You will gradually learn the quirks and nuances of the film reacting with the solution, and once you can recognize the developing physical characteristics of the various stages in the process, you will lose fewer negatives. In the beginning, few of your attempts will be successful. Gradually, the percentage of successes increases, and you will develop a good average in successful reticulations. You will find yourself involved in a process of discovery as you work with the dissolving images and begin to manipulate and remove part of the emulsion to alter and shift normal expectations of visible reality.

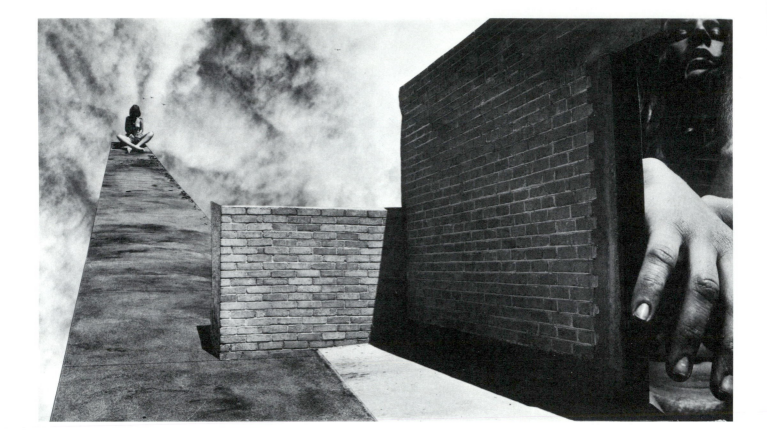

PHOTOMONTAGE
Allen Dutton

I grew up in an era when much art was influenced by Freud. Surrealists were intrigued by Freud's theories of the dynamic effect of unconscious processes on consciousness and action and the central role of mental conflict in development. His belief that the world of the unconscious mind, as expressed by fantasies and dreams, has a reality superior to that of the phenomenal world became an influence on many painters. I was introduced to surrealism early and found great satisfaction in the work of Magritte, Tanguy, and Dali. When I became a painter it was natural that I turn to surrealism. Photography seemed to me to be less effective than painting in dealing with these concepts until I began to experiment with the montage. I began to assemble prints and developed a style much more akin to painting than to anything that photographers had been doing. After I began this work, I discovered the photomontages of artists like Man Ray and concluded that their juxtapositions and transitions were too abrupt and undreamlike, or that, as in most multiple printing, their imagery was too studied.

I begin my own work by photographing anything that interests me without regard to how I will work the images into a montage. I attempt to let my subconscious dictate not only the subjects I photograph, but also how I assemble them. My selection of lens, camera angle, and lighting are all done without study. I use whatever feels appropriate. After processing and proofing I select negatives quickly, making many prints of various sizes. Over the years I have accumulated hundreds of pictures which I keep readily available. When I get ready to montage I use a large room, where I lay out a great many prints. I then select several backgrounds, preferring to have various picture areas ready to be populated before I begin assembly. The assembly is done intuitively, and the elements I choose must seem right immediately. The picture is finished when I feel it is.

With this method of spontaneous montage I am more free to express my subconscious than I ever was when I painted, because each step in the process requires little conscious thought. The simpler the step, the easier it is to bypass my conscious mind, of which I am already all too aware. I work for dreamlike imagery, not for specific images of my dreams. Any attempt to recall specific parts of dreams obstructs the revelation of the unconscious through spontaneity. I attempt to make my pictures look like dreams I might have had.

I try to achieve images that accurately reflect my subconscious. Believing as I do that my psyche is not at all unique, I have faith that my images will mirror the subconscious minds of others. That my pictures are disturbing, not only to me but also to many who look at them, convinces me that they function as windows through which we see things we would prefer to keep hidden from others and from ourselves. At this point, understanding and self-knowledge become real possibilities.

Setting Up

It is not necessary for you to adopt Freudian attitudes to utilize the techniques of the montage. These construction skills will enable you to assemble many separate images into a single picture. Probably every photographer, at some time, has wished that a particular image was different. The montage makes any alteration possible. The extent of reconstruction is limited only by the artist's degree of skill.

Assemble a large group of prints. The larger the selection, the more your imagination will be stimulated. A few prints of open and uncluttered landscapes are also necessary. Think of each print as a stage on which you can produce a play. Generally the less cluttered the print, the more opportunity it presents. In addition to these background pictures, it is helpful to have several sky negatives. I prefer to print both the sky and the background 16x20. This large size allows more freedom; mistakes are less noticeable because the final prints are usually smaller than these originals. If you do not have facilities to print this size, work as large as possible.

These open landscapes make ideal backgrounds upon which to montage other images.

Common equipment is all that is necessary for photomontage.

Collect the following:

1. Large dimension dry-mounting tissue. I prefer a 20″ roll. If you do not have the facilities for dry mounting, spray adhesive will do. Avoid glue or pastes that are not easily removed from prints.

2. Dry-mount press.

3. Tacking iron.

4. Several sheets of medium-weight illustration board that are larger than your background prints.

5. Small bottles of neutral-colored spotting liquid.

6. A number 1 or 2 high-quality brush. A good spotting brush is ideal.

7. A sharp pair of scissors with comfortable hand grips.

8. A sharp X-acto knife.

9. Several fine-tipped felt pens in varying shades of gray. These are available at any good art supply store.

• Copy stand or copy lights.

• A camera and tripod for copy. I use an 8x10 view camera and a 2¼″ square roll film camera. I prefer the quality of contact prints, but find the smaller negative necessary to make larger prints, as I do not have an 8x10 enlarger.

Assembling the Montage

Spread out all the images you think you might possibly use. Remember, the more the better. Try several different prints against a background until you find some that work. When this preliminary selection is made, cut away most of the background from the images you want to use.

Lay the rough-trimmed prints back down on the background. When you are sure you have the ones you want, adhere dry-mount tissue to the back of each, using a number of passes with the tacking iron.

Open sky and landscape backgrounds should be spread out to present possibilities.

Try various combinations before deciding to cut any prints.

The final form begins to take shape as rough-trimmed prints are set on the background.

Cut out the prints to their final size. Make long, continuous cuts, the longer the better. Short scissor strokes have a very rough appearance. The first cut should be the only one necessary. It will become easy with practice. Correcting uneven cuts or mistakes is time-consuming and nearly always detectable. Whenever possible, bevel the cut by canting the scissors, giving the edge an undercut. This will help make the cut edge undetectable in the copy print. Use the X-acto knife only to accomplish cuts which are impossible with scissors. Lay the pieces out on the background again to make sure they produce the image you want.

Color the edge of each piece using the appropriate shade of gray felt pen. Areas where the print is very nearly white need not be touched. Remember, too dark an edge can be just as discernible as one that is not toned at all.

Beveling the cuts by tilting the scissors will make the cut edges less detectable.

The edges should be shaded in matching tones with gray markers.

Mounting and Copying

Mount the backgrounds on the illustration board using the dry-mount press. If you use a separate sky and ground to make one background, mount the sky piece first, then the ground. If you use spray adhesive, be careful to lay the pieces face down on clean paper before spraying. It may be necessary to hold smaller pieces down with the point of a pencil to keep the spray from blowing them away. When tacking down the pieces before dry mounting, begin at the top of the background piece and work down toward you. After carefully positioning the pieces, tack them with the dry-mount press lightly and check each before finally adhering them.

Add shadows by spotting them in. After every piece has been adhered, it will probably be necessary to fabricate shadows to integrate the added image areas. Cut out a cardboard arrow and place it near the top of the picture to remind you of the light direction. Sketch in each shadow with dilute Spotone, making certain it is correct before completing it with the full-strength liquid to make a convincing shadow.

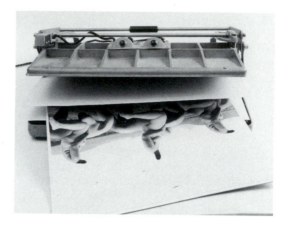

When all the pieces have been carefully cut and shaded, they are dry mounted onto the background.

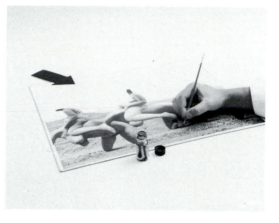

Adding the shadows with a spotting brush is necessary for realism.

Make a copy negative. Once the assembled print is visually convincing, make a copy negative from which to make prints. Eliminated in these final prints are the surface differences noticeable in the montage. Set two lights at 45° angles, measuring the distances for accuracy. Make certain the lights are not too close to cover evenly. If you use a view camera, it will be much more convenient to tape or tack your montage to a wall so the camera can remain level. Determine your exposure by reading an 18% gray card. Several graphic arts sheet films are manufactured specifically for copying photographs; these will give the most satisfactory results. With roll film cameras, use the slowest fine-grain film available. Manipulation of the final print can correct minor value discrepancies of different prints, but not wide variations in contrast.

Make the largest copy negative your equipment will allow. The lights should be positioned carefully for even illumination.

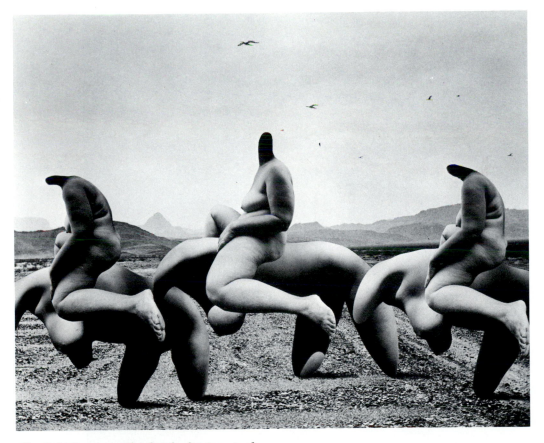

The Gobi Caravan. *The finished print, made from a copy negative, shows birds added to the sky with the spotting brush.*

Gallery

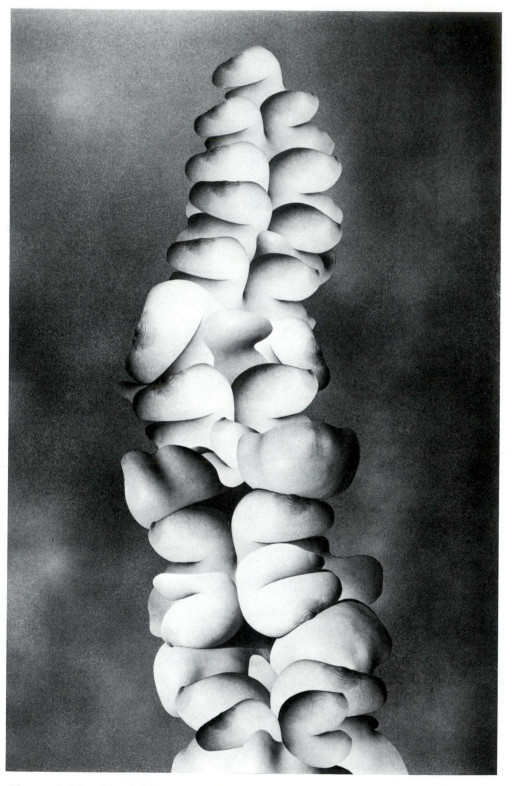

The growing tip of Fondella's Neebooboblast

An anonymous studio photographer created this photomontage, found in an old album of similar portraits.

John Heartfield, *finding the techniques of photomontage suited to the expression of his political and visual convictions, created brilliantly original anti-fascist propaganda between the world wars. Heartfield's title in this 1935 piece reads "Hurrah, the butter is all gone." The caption below is from a speech made by Goering in Hamburg: "Iron has made an empire strong, butter and oil have only made the people fat."*

COMBINATION COLORING
Benno Friedman

This is interesting, this photographic cookbook written by numerous chefs who may have never met, whose recipes may not be compatible on the same table, and who most importantly may disagree in the fundamental areas governing basic relationships between photographer and photograph. Moreover, it is assumed that we are specialists in the respective fields we are writing about, whereas my own photographic existence has been nurtured by an almost compulsive rejection of the notion of specialization, of becoming too familiar with what one already knows. It is so easy for a process to become *the process.* There are only processes and techniques, a tactile, sensuous array of machines, fluids, powders, papers, and the still-elusive phenomenon of light — the building blocks of a visual language made manifest in every photograph. Working with any process or combination of techniques does not ensure originality, creativity, or even minimal visual interest.

There is at the present time an increasing amount of attention being paid to the technical aspects of photography, perhaps at the expense of the subtleties of content and aesthetics. Each month the magazines are filled with extensive how-to articles, yet the photographic content remains unchanged: children with kittens, girls in bathing suits. It is the photographic industry, motivated by economic considerations, that has promoted the idea of an inflexible equation between software (visual excitement and quality) and hardware (sophisticated equipment and materials). This equation implies that to take the best pictures one must own not only the best cameras, but all of the attachments, lenses, enlargers, and accessories that can be marketed as absolutely essential. It would be equally mistaken to assume that the application of any of the processes outlined in this book to weak imagery would result in anything other than jazzed-up-but-still-weak imagery. These techniques are not endpoints, but beginnings, directions, and inspirations. Perhaps the most important chapter of this book is missing, the one with the blank pages to be written by you so that a dialogue would ultimately replace this compilation of monologues. It is this dialogue between the known and that which will become known that forms the solid core around which my work, and perhaps all creative work, revolves and takes shape.

After an initial apprenticeship to the basic photographic disciplines of exposure, development, and printing, I felt myself becoming trapped and consequently bored by the more mechanical aspects of photography: the repetition of identical prints and the concept of the perfect print according to an external definition of perfection. The magical, alchemical experience of the darkroom was becoming habitual. I became increasingly aware that the excitement of the act of photographing was not being equalled in the darkroom. Creativity is a transformational activity and the repetition of mechanically lifting rectangles from the flow of visual information began to seem a half-completed business. Ultimately the concept of making photographs superseded that of taking them; a predominantly passive relationship gave way to a more consciously active one. Among other possibilities, I began to explore the idea of altering the emulsion of the black-and-white print through photographic chemistry. The formulas I use are not, with few exceptions, newly devised. It is their application, or more appropriately their misapplication, that has produced many of the directions my work has taken. The fixed and washed print is to me what the stretched white canvas is to the painter. The photographic imagery exists somewhere between total dominance and total disappearance, no more or less important than the photographic qualities of the original photograph itself.

Setting Up

On these pages the illustrations and text follow the transformation of one image. I have used two commercially available coloring agents, Edwal toners and Develochrome color developers, which represent two of several available coloring processes. The Edwal toners combine potassium ferricyanide, a bleaching agent, with a stain or dye. Their long-term stability is questionable, since the coloring agent may be a coal-tar derivative (as are many of the commercially available liquid dyes, such as Dr. Martin's). These are known to fade with continued exposure to light, although this is not true for Edwal blue, which is an iron toner rather than a dye. These toners do not chemically bond with the silver salts and therefore caution must be used in washing the prints after toning, as the colors may diminish with prolonged washing. They may partially stain each other if two prints are left touching emulsion to emulsion when wet. The color intensifies as the image fades because of the bleaching action, making Edwal toners part of a larger group of replacement toners.

Develochrome, on the other hand, is a dye-coupler developer; it depends on an initial bleaching of the print, which is then redeveloped with a color-coupler, actually changing the chemical makeup of the emulsion. Though the colors are not as intense, these toners appear to be more stable due to the manner in which they affect the print. Develochrome toners can also be used as original developing agents if employed according to the instructions enclosed in the package. Unlike

The coloring agents used in the examples following are chemical toners made by Edwal and a color developer manufactured by Develochrome.

178

Edwal, they oxidize and exhaust rapidly once they are in liquid form and must be mixed immediately prior to use.

In preparation for toning, nothing out of the ordinary need be done to black-and-white prints. Certain coloring processes are much more effective if a nonhardening, nonacid fixer is used. This is especially true for Develo-chrome when used as an original developer; the acid in a stop bath or in normal fixer is enough to eliminate nearly all the tone in the print. Also, all prints to be toned must be thoroughly washed of all residual fixer. Spots, discolorations, and strange markings may appear during toning on an improperly washed or fixed print.

The first bath in this series is a bleach bath made by dissolving potassium ferricyanide in water. Several different useful formulas for bleaching agents exist. Each step and all the variations possible within that step affect each succeeding step in different ways. Different papers, print densities, strength of bleaches and toners, and length of time in each tray produce a wide range of results that can be controlled and duplicated only as you become familiar with them through experimental practice. Even the steadily decreasing amount of silver used in the manufacture of paper emulsions has had an effect on the way prints respond to toning. As you become familiar with the processes and the materials, you will begin to understand what combinations work best together.

Coloring the Print

I begin with a completely fixed and well-washed print. It has been printed slightly dark to leave more available silver for later bleaching and redeveloping.

I have partially bleached the print, leaving it in a tray of bleach long enough to reduce but not remove the image. The amount of bleaching is a specific choice made in relation to the application of toners two or three steps away. All these decisions are aesthetic choices based on empirical darkroom experiences and represent perhaps the most flexible area of darkroom procedure.

The blue color is applied with a piece of paper towel soaked in Develochrome blue. A sponge, Q-tip, or rag will work as well, your choice depending on the size of the area to be toned. The blue-colored area has a more visible sky and clouds, as partial redevelopment has taken place. For richness of color, I have found the resin-coated papers to be particularly satisfactory. The plastic base is nonabsorbent and therefore the toner's strength is directed completely at the emulsion. Unfortunately several undesirable qualities, including poor long-term storage life, make most resin-coated papers unacceptable for me at this stage in their evolution.

I have added Edwal yellow to the bottom of the image. If I had previously bleached out the image completely, the Edwal would not have been the appropriate coloring agent. The lower area has lost noticeable detail from the toning. The amount of time the Edwal is left on and the concentration of the solution directly affect the amount of image remaining and the intensity of its color.

Colors can be mixed either before application to the print or directly on the print surface if a greater palette is desired. Expect the tones to change during washing and drying and especially with heat drying. Many times after a print has dried I have found it necessary to resoak and retone it. Air or blotter drying helps minimize this, but you can still expect changes.

Where the Edwal and the Develochrome meet at the blue-yellow junction, a no-tone-zone is formed. The bleaching action of one is counteracted by the developing action of the other. This pitting of opposing forces can result in some visual magic, but in this print I have washed it to stop all activity.

Combination Coloring 181

Coloring the Print, cont.

I then partially rebleached the top half of the photo, applying the bleach by hand. The bottom half is incapable of withstanding more bleaching, yet the top cannot be retoned with a developing toner unless bleached. This bleaching intensifies the blue as well as preparing it for receiving additional Develochrome toners, in this case red. The red also mixes into the Edwal yellow, partially redeveloping it. If a more intense red is desired, another rebleaching step can be made in the Develochrome red area, eliminating the black developed silver and leaving only the pure color. In addition to applying Develochrome red to the blue-yellow combat zone, I added it around the borders of the print, working in the above-mentioned manner.

The last phase of this series is the Develochrome green step, applied to the bottom of the Edwal yellow area, and again acting as a redeveloping agent to the part of the photo that had been bleached out by the Edwal toner's activity.

Six prints were made in six stages for illustration purposes, and they demonstrate the near-impossibility of achieving repeatable results in this multistep, hand-applied toning. The colors, the clarity of image, and the border stains all vary. Among five or among fifty prints it becomes a matter of personal aesthetics to decide which one is the superior, or even the finished, piece.

Any number of different toners — in this context even Dektol is a black toner of sorts — that work in combination or in opposition can be used in succession. Some of them, such as the two types discussed here, are open ended and some are closed. By closed I mean that once a print is subjected to a selenium toner, for example, the process is nearly irreversible. It seems to stay unchanged regardless of what other toners are applied to it. Sodium sulfide also seems to be a closed treatment, but these are things to be discovered in your own darkroom. At this point, I have arbitrarily decided that this demonstration image is finished. As each bleaching and redeveloping tends to degenerate the image quality, I could continue bleaching and redeveloping it until nothing remained but near-invisible imagery tinged with color, a color-field photographic abstraction. It is these changes, some immediate and some slowly made, that I have found to be so incredibly exciting. But as I have already mentioned, the next move is yours.

Take every precaution to avoid poisoning yourself. Some of the individual chemicals required for more innovative, nonpackaged toning, as well as combinations of apparently dormant and harmless chemicals, are quite toxic or otherwise hazardous. Work according to strict laboratory procedures regarding the safe handling of materials, adequate ventilation, and obtain technical assistance from a chemist when using unfamiliar chemicals.

DYE TRANSFER
Kenda North

A process used by an artist should be a tool for the visualization of ideas. The evolvement of my work in dye transfer has been based on the premise that through chance, accidents, skill, and courage, materials intended for one thing can be made to do something quite different.

Dye transfer was originally introduced by Kodak in 1946 as a means of reproducing a full-color print from a color transparency. The process involves the making of three separation negatives from the original transparency and exposing these to three sheets of matrix film, which are processed, dyed, and printed in register on a single sheet of paper. The process is widely used in this manner, and the final prints are valued for their richness, stability, and fidelity to the original.

The inherent flexibility of the process has intrigued creative photographers since its introduction. In the late 1940s, Henry Holmes Smith chose it when looking for a material that "would produce the most desirable approach to the study of the possibility of color photography as a medium for creative expression with abstract play of light." Smith's early works were photograms made by exposing glass coated with heavy syrup to intermediate negatives and then matrix film. The sheets of film were multiple-printed to create abstract studies of transmitted and absorbed color.

I began using dye transfer out of frustration with the limitations of conventional color materials. The color of the finished print never looked the way I had originally envisioned it through the camera. I was looking for what Syl Labrot spoke of as "color as an exact re-creation of the sensations of realism." The perception of color is a sensory act and a subjective response. We say that the sky is blue, but cannot express the range of blues that one can see from dawn to dusk. My interest in dye transfer evolved out of the desire to modify the extant realism of the photograph and to persuade the viewer to feel more of my perceptions.

Hand coloring by dye transfer is a lengthy and intimate process. Although the processed matrix is transparent, it contains all the tones of the negative. I mix the yellow, magenta, and cyan dyes into the desired hues and selectively work them into the image with soft brushes. My color choice is usually a spontaneous response to the emerging tones and colors. I often try to make the relationship of the color to the image raise questions. I can use a flesh tone that appears real and make the shadow cast by the figure blue. What color is a shadow? I can set the figure into a tension created by complementary colors formalizing the relationships between specific areas of the image.

My recent work has been a series of pictures exploring the sensuous and tactile relationship of a figure to color, fabric, and light. The sensuality is often suggested by the closeness, anonymity, and narcissism of the images.

The application of color to make a unique print is often frustrating, but it encourages me to learn about the use of color. Fortuitous accidents still happen with the materials, leading me to new areas of invention and surprise.

Setting Up

The process outlined here is a modified and simplified version of the Kodak Dye Transfer procedure. The information comes from several sources, particularly from Henry Holmes Smith and Larry McPherson, and from a great deal of trial and error.

Dye transfer was introduced in 1946 to replace its predecessor, the Wash-Off Relief Process. Called an imbibition color process, dye transfer is commonly used to make extremely high-quality prints from color transparencies. It utilizes the principles of color reproduction developed by physicists during the nineteenth century.

To make a full-color print, the color of the original transparency is first separated into its primary-color components onto three sheets of black-and-white negative film by enlargement through red, green, and blue filters. These separation negatives are then color-corrected by a series of masks and exposed onto Kodak Matrix Film. These matrices, when processed, become positives with each emulsion forming a gelatin relief. In other words, shadow areas of the image leave thick gelatin on the matrix, while the highlight areas are represented by a thin layer of gelatin. These matrices are soaked in dyes of the secondary, or subtractive, primary colors: yellow, magenta, and cyan; and individually printed in register on one sheet of receptive paper.

Used to make full-color prints, the dye-transfer process requires specialized equipment and demands extensive testing to produce satisfactory results. It rarely is used outside sophisticated custom-color photographic labs in larger cities.

Used experimentally, for unrealistic or hand-applied color, prints can be produced with little beyond standard black-and-white darkroom equipment. The matrix film can be exposed with one or several black-and-white negatives. The color can be worked into the image by applying the dyes to the matrix by brush or by soaking, and they can be printed in or out of register. When used in this manner, the process is very flexible and you will find that it can be modified to produce an incredible range of visual ideas.

The following processing instructions differ from those published by Kodak for its dye-transfer products. Matrix film has an unhardened gelatin-silver emulsion coated on an acetate film base. During processing, the exposed gelatin is hardened, or tanned; then the unexposed gelatin is washed away, leaving the relief image. The Kodak process uses a tanning developer and leaves a silver image in the film. In the wash-off relief process, the R10A bleach tans the gelatin and bleaches the silver out. This enables you to see the applied color in the matrix and preview how it will print.

The Materials

In addition to the contents of a normal black-and-white darkroom, you will need the following special equipment to make dye-transfer prints:

1. Kodak Dye Transfer Paper Conditioner, Catalog No. 1465814, is available as a stock solution, which is diluted with distilled water to make one gallon. Paper conditioner has a long shelf life although eventually it will become too acidic, affecting the transferring.

2. Kodak Matrix Dye Set, Catalog No. 1465798, includes dye concentrate and dye buffer to make one gallon each of magenta, yellow, and cyan. Also available is a five-gallon size. Dilute the dyes according to directions and be sure to use distilled water.

3. Kodak Matrix Film 4150 is available in standard sizes from 8x10 to 20x24. The film is often manufactured a little larger to accommodate holes punched for registration.

4. Kodak Dye Transfer Paper is also available in standard sizes from 8x10 to 20x24. Unfortunately, the paper is packaged only in large quantities. Other photographic paper can be mordanted to accept the dyes according to Kodak's instructions.

Note: The above materials are available only from professional photo stores. They usually have to be special ordered, and delivery can take up to eight weeks.

5. 2% Acetic Acid Solution is made by diluting glacial acetic acid (see Formulas, p. 194). Although Kodak recommends a 1% acid solution, most labs find a 2% solution to be preferable.

6. Roller or Squeegee should be large enough to cover the size print you are making.

7. Condit Register Strips are stainless steel register strips 6½" or 9". Order according to the size film you are working with. Use the strips with the high pins. These are available from Condit Manufacturing Co., Sandy Hook, CT, 06482.

8. Adjustable Paper Punch. The Kodak Register Punch is efficient and precise but expensive. An adjustable paper punch will suffice for film sizes up to 11x14.

9. Trays should be plastic with flat bottoms. Trays with ridges will scratch the film.

• **Printing board** can be made by epoxying a Condit Register Strip to a heavy sheet of glass. Be sure to glue it so the pin side is placed toward the center of the glass. Registration boards are available from Kodak but are very expensive.

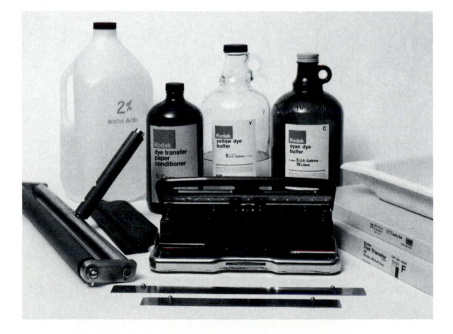

The Wash-Off Relief Process

For steps 1 through 4, use a red 1A safelight or the equivalent. All processing, including exposure, should be done with the matrix film emulsion side *down*. The emulsion of the film is very sensitive. Take great care to avoid scratching it. When transferring the film from one chemical bath to another, submerge the film carefully to avoid streaking. Agitate the film in the trays constantly and gently. When processing more than one sheet of film, agitate by moving the bottom sheet to the top repeatedly.

1. **Expose** the matrix film through the base with the emulsion face-down on the easel. As with all sheet film, the emulsion side is up when the notched corner is on the upper right or lower left. If you forget and expose the film through the emulsion side, the entire emulsion, image and all, will wash down the drain during step 5.

2. **Develop** in DK-50, a packaged Kodak developer, for 5 minutes at 20° C. A more readily available substitute is Kodak HC-110 developer. The contrast of the film can be modified by diluting the developer. HC-110 diluted 1:4 from the stock solution is equivalent to straight DK-50.

3. **Rinse** in water for 3 minutes at 20° C. Use two trays and transfer the matrices from tray to tray, making several water changes.

4. **Bleach** in R10A for 3 to 5 minutes. The formula is given on page 194. The silver image will gradually fade. Wear gloves for this step.

Steps 5 through 9 can be carried out in room light. The matrix film is now processed one sheet at a time with the emulsion side *up*.

5. Rinse the matrix in hot water, approximately 30° C. Make several water changes and gently agitate the tray until no milkiness remains on the film. This washes the unexposed gelatin off the film, leaving the image in relief.

6. Rinse the film in cool water for 1 minute.

7. Fix in plain hypo (without hardener) for 3 minutes at 20° C.

8. Wash in running water for 2 minutes. If your tap water is heavily chlorinated, use bottled or distilled water for a final rinse.

9. Dry the film in a dust-free environment. When the film has dried completely, store it in a soft plastic or paper folder for protection.

Exposure

To determine your initial exposure, use your normal test-strip technique. The image visible before the bleach step will be an indication of satisfactory exposure, although the final print will be your best reference.

Matrix film is equivalent in contrast to a grade 2 Kodabromide paper. Your exposure will depend on the image you want, but I recommend using contrasty negatives. When exposing, leave borders for handling the film and one larger border for punching the film later. The developer and bleach should be discarded after processing, but the fixer can be reused until exhausted.

To make several matrices for printing in register, punch the film before exposure and use the printing board with register strips as an easel during exposure.

Dyeing the Matrix

On the right is a sheet of unprocessed matrix film. An exposed and processed sheet is in the tray on the left. The image in relief is almost transparent. The matrix will absorb dye in proportion to the amount of gelatin that has been exposed: a shadow area will absorb more dye than a highlight will. The Kodak Register Punch shown is useful for ease in printing and essential for critical registration. An adjustable paper punch can be used for smaller film sizes.

Place the matrix in the tray, emulsion up, and apply one color to the entire image. I've mixed several colors from the yellow, magenta, and cyan dyes. Black is made from approximately equal proportions of all three dyes.

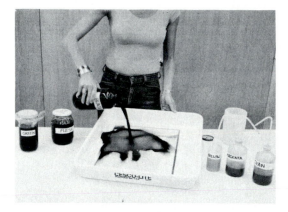

The matrix will fully absorb the dye in 3 to 5 minutes. Constant agitation will help it absorb more evenly.

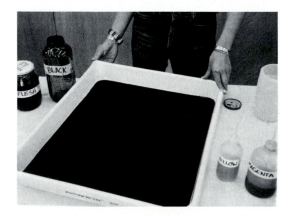

After pouring the dye back into its container, rinse the matrix in the 2% acetic acid solution. The acid solution rinses away the excess dye and sets the dye on the matrix. The acid can be used until it becomes discolored. I usually mix up several gallons when printing.

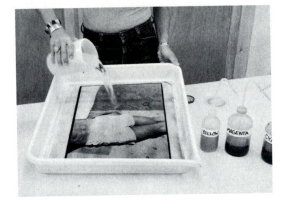

If desired, the dye can be removed from the matrix by rinsing it under warm water or by soaking it in a tray of fairly hot water. This technique can be used for several purposes. The highlights will rinse away first, which will increase the contrast of the image. Increasing the contrast can be done more precisely by using Kodak Highlight Reducer, listed on page 194. The warm water rinse will also desaturate the color and eventually will wash it away completely.

If you use a warm water rinse, soak the matrix again in the acid solution to set the dye.

Printing the Matrix

After drying the matrix, which can be done rapidly with a hair dryer, you can selectively color the matrix. I work with very soft brushes, using the acid as a diluting agent, and slowly add the color to each area. After each application of dye, the matrix should be rinsed in acid and dried. The final printed image will be very close to what you see in the tray. If you haven't already scratched the matrix during processing, you will find it very easy to do it during the coloring. If you do, try to make creative use of the scratches and continue to manipulate the image. If the gelatin is rubbed or scratched off the matrix it will not accept dye and will print white in those areas.

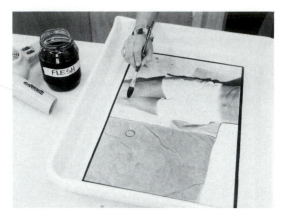

After the matrix has been dyed to completion, soak it in a tray of clean acid solution. The dyed matrix must be thoroughly wet before printing. Presoak a sheet of Kodak Dye Transfer Paper in warm water for several minutes, then place it in Kodak Paper Conditioner. The paper should soak in the conditioner for at least 10 minutes and can safely be left for several hours.

Remove the paper from the conditioner and place it on the printing board, emulsion up, with one edge butted against the register strip. Wipe the excess conditioner from the paper and rinse the solution from your hands. Lift the matrix from the acid tray and allow it to drain for a few seconds. With the emulsion side facing the paper, hold the matrix up and affix the punched edge to the pins on the register strip. Continue to hold one end away from the paper as you slowly roll the matrix into contact with the paper, using a roller or squeegee. Be firm enough to squeegee any air bubbles out; excessive pressure is not advisable.

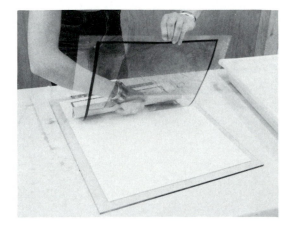

The transfer of the dyes is a simple chemical process. The film has been rinsed in the acid solution and the paper soaked in the alkaline paper conditioner. When rolled into contact, the dyes will migrate to the surface of lesser acidity.

Leave the matrix and the paper in contact for 3 to 5 minutes. It often helps to use heat when printing: you can either warm up the board by rinsing it under hot water before printing or place a warm sponge over the matrix while it is in contact with the paper.

Lift the matrix slowly from the paper. Before removing the matrix from the pins, check for areas where the dye hasn't transferred. If there are any, splash some paper conditioner on the print and roll the matrix down again.

If you wish to make multiple printings in register on the same sheet of paper, take care not to move the print on the board. The paper must be kept wet with paper conditioner between printings. If you cover the print with a sheet of clear acetate, it will keep the paper wet and allow you to lay the dyed matrix over the print to visualize how the color will look.

After the dye has transferred, squeegee or sponge excess moisture from the print and dry it on a screen. The matrix can be rinsed in water and hung to dry or returned to a dye bath for another print. The matrices can be dried and stored with the dye on them. To print a matrix at a later date, rinse the film in the acid solution and proceed as usual.

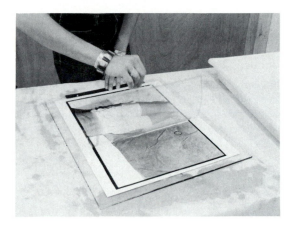

Other Possibilities

Other possibilities for control and manipulation of the process are the masking out of image areas and printing on other surfaces. Masks made from litho film (see the chapter on high contrast, p. 108) can be used to leave certain areas of the image unexposed on the matrix. You can mask the processed matrix directly, using Photo Maskoid or rubber cement.

In lieu of Kodak Dye Transfer Paper, the dyes can be transferred to any fresh or out-of-date photographic papers. To prepare (mordant) the paper, fix in Kodak Photo-Fix or Kodak Fixing Bath F-5 for 3 minutes and then wash thoroughly to remove the residual hypo. The paper can then be dried or placed directly in paper conditioner.

The dyes can be transferred to a processed black-and-white print if it has been mordanted with Photo-Fix or F-5.

The dyes can be transferred to other materials, such as fabric, but there must be a gelatin base to retain image sharpness.

For further information on the process, see Kodak publication E-80, *Kodak Dye Transfer Process.*

Formulas

Plain Fixer

> 450g sodium thiosulfate
> 2000ml water

Dissolve the sodium thiosulfate in the water at 52° C and allow to cool before using. A liquid rapid fixer can be used, mixed as directed without the hardener.

R10A Bleach

Part *A*:

> 20g ammonium dichromate
> 4ml sulfuric acid
> 1000ml water

Dissolve the ammonium dichromate in half the water at room temperature. Add the sulfuric acid, then the remaining water. Handle the acid with great care, and always add acid to water, not the reverse.

Part *B*:

> 45g sodium chloride
> 1000ml water

Mix at room temperature. Non-iodized table salt is sufficiently pure sodium chloride for this use.

To make a working solution of R10A bleach, mix 1 part of Part *A* and 1 part of Part *B* with 6 parts of water.

2% Acetic Acid Solution

> 20ml glacial acetic acid
> 1000ml water

Mix acid into the water carefully at room temperature. Do not add water to acid.

Kodak Matrix Highlight Reducer R-18

> 1.2g Calgon dishwasher detergent or
> sodium polymetaphosphate
> 1000ml water

Mix together at 32° C. Add 50ml of this solution to a liter of the acid solution and agitate the matrix in it for 1 minute to clear the highlights.

Kodak Matrix Clearing Bath CB-5

> 120g Calgon or Kodak Anti-Calcium
> 35ml ammonium hydroxide
> 1000ml water

Mix the Calgon and ammonium hydroxide into the water at 32° C. To make a working solution, dilute this stock solution 1:11 with water. To remove residual dye from the matrix, rinse in the working solution. Follow with a running water wash and a rinse in the acid bath before applying dye again.

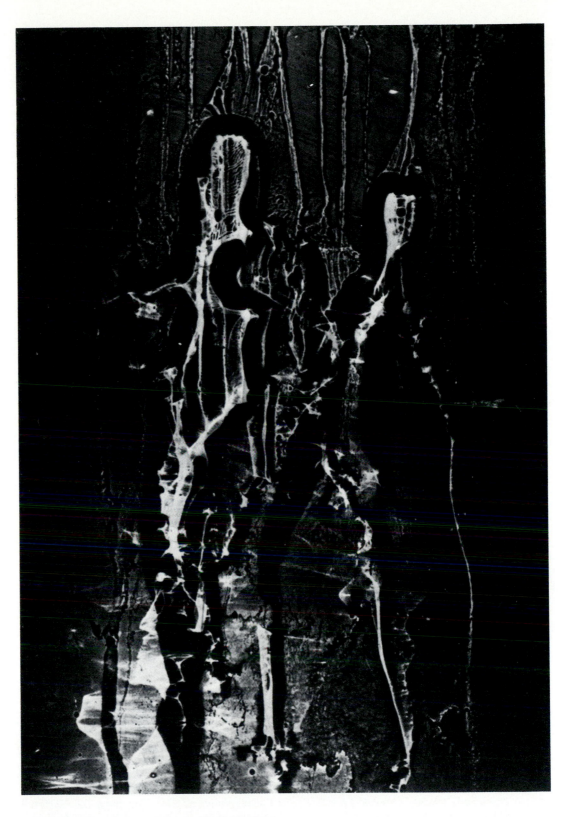

Royal Pair was made in 1951 by **Henry Holmes Smith,** one of the earliest experimenters with artistic use of photographic color process. This dye transfer print (the original is in color) began with photogram "negatives" of syrup on glass. The matrices made from these nonobjective glass plates were printed out of register to achieve the subtle blending of color.

ABOUT THE AUTHORS

Dick Bartlett, currently a photogrammetrist with the United States Geological Survey, received his M.F.A. from the Rhode Island School of Design. His work has been published in the Aperture book *Celebrations* and in *Courthouse*, the Seagrams-sponsored Bicentennial project.

John Craig has been on the faculty of Franconia College and the School of the Art Institute in Chicago. He received a National Endowment for the Arts Fellowship in 1976 for his work in Photogravure. He has an M.F.A. from the University of Florida.

Allen Dutton teaches photography at Phoenix College in Arizona. He has published two monographs of his work, *The Great Stone Tit*, and *A.A. Dutton's Compendium of Relevant but Unreported 20th Century Phenomena*; and has had portfolios in *Aperture, Album, Creative Camera, Popular Photography*, and *Modern Photography*. His one-man shows span the United States, and include Montreal, Milan, Florence, Rome, Paris, Tokyo, Mexico City, and London.

Benno Friedman is represented by LIGHT gallery in New York, and has exhibited widely, both in the United States and abroad. His work has been included in *Art in America, Being Without Clothes, Light and Lens, Masters of the Camera*, and *Private Realities*. He is also well-known for his commercial work, which includes fashion and record jackets.

Gary Hallman has been published in the exhibition catalogs *Light and Lens*, Morgan and Morgan; *Fourteen American Photographers*, The Baltimore Museum of Art; and *Mirrors and Windows*, The Museum of Modern Art. He has been on the faculty of the University of Minnesota since 1970, and was Visiting Adjunct Professor at the Rhode Island School of Design in 1977–78. He received a Photographer's Fellowship in 1975, and a Survey Project grant in 1976 from the National Endowment for the Arts.

Christopher James has had one-man shows at Archetype Gallery, Rosa Esman Gallery, the Minneapolis Institute of the Arts, The George Eastman House, and the Carl Siembab Gallery. His work has been published in *American Photographer, Popular Photography, Annual*, and *Camera 35*. The recipient of a Photographer's Fellowship from The Artist's Foundation in Massachusetts, he is currently teaching photography at Harvard University.

Michael Kostiuk, a native Texan, was a commercial photographer, cinematographer, and gallery director before devoting full time to commissions and installations of his art. His one-man exhibitions include the Amon Carter Museum, the New Orleans Museum of Art, and the Polaroid Gallery.

Peter Laytin began in photography as an apprentice to Minor White. He went on to teach at the Massachusetts Institute of Technology, and is currently Assistant Professor at Fitchburg State College. His work has been exhibited widely in the United States and Europe, and published in *Aperture* and the *British Journal of Photography*.

Greg MacGregor was a physicist before studying photography at San Francisco State University. He has been Assistant Professor at Lone Mountain College in San Francisco since he originated the photography program there in 1970. A book of his photographs entitled *Deus Ex Machina* was published in 1975.

Kenda North received her M.F.A. through the Visual Studies Workshop and taught at the School of the Art Institute of Chicago. Portfolios of her work have appeared in *Afterimage, Camera Mainichi, Le Nouveau Photocinema, Popular Photography Annual*, and the *Time-Life Library of Photography*. She received a Photographer's Fellowship from the National Endowment for the Arts in 1977, and has exhibited and lectured widely.

Olivia Parker came to photography from painting. She has produced a portfolio of her work, entitled *Ephemera*; a monograph, *Signs of Life*, was published by David Godine in 1978. She is represented by Vision Gallery in Boston, and has exhibited at Archetype Gallery, Focus Gallery, and the Boston Museum of Fine Arts. In 1978 she received a Photographer's Fellowship from The Artist's Foundation in Massachusetts.

Rosamond Wolff Purcell, largely self-taught as a photographer, has published portfolios in the *British Journal of Photography, Modern Photography, Ms. Magazine, Popular Photography, Print Letter,* and *35mm Photography.* A monograph of her work, *A Matter of Time,* was published in 1975 by David Godine, and her work has been exhibited widely in the United States and Europe.

Daniel Ranalli is currently the director of the Artist-in-Residence program for the Artists Foundation in Massachusetts. He received a Visual Arts in the Performing Arts grant from the National Endowment for the Arts, and has had one-man exhibits at M.I.T., Foto Gallery, the Portland School of Art, the Carl Siembab Gallery, and the University of Maine.

Gail Rubini, now a Resource Coordinator for the Chicago Council on the Fine Arts, received her B.A. from UCLA, and her M.F.A. from the Rhode Island School of Design. She taught at Columbia College and the School of the Art Institute in Chicago, and is a co-founder of Chicago Books, a publishing group producing visual books by artists.

J. Seeley has been Assistant Professor of Art at Wesleyan University since 1972. Portfolios of his work have appeared in many photographic periodicals published in the United States, Germany, Greece, Japan, Spain, and Switzerland. He received grants for individual work in photography from the Connecticut State Commission on the Arts in 1976 and 1978.

Michael Teres is currently Associate Professor at the State University of New York at Geneseo, where he has been teaching since 1966. His work has been published in *Exposure* and *Creative Camera,* and in the exhibition catalogs *Light*[7] (Aperture), and *Vision and Expression* (Horizon Press). In 1975 he received a Creative Arts in Public Service Grant and in 1975 and 1978 received Collaborations in Art, Science, and Technology Grants from the New York State Council on the Arts.

INDEX

Adams, Ansel, 71

Bas relief, 16
Bleaching, 14–15, 92, 178–183, 188–189

Callahan, Harry, viii, 60
Color-key, 132

Dadaist, 33
Dali, Salvador, 167
Develochrome, 178-182
Diazo, 132
Dyeing, 93, 190–191
Dye-transfer, 132, 184–195

Enameling, 93
Estabrook, Reed, 95

Fichter, Robert, 3
Filters, 22–24, 56, 111
Fine-line developer, 138
Fox-Talbot, William Henry, 33
Freud, Sigmund, 167

Gleber, Conrad, 151

Heartfield, John, 175
Heinecken, Robert, 33

Infrared film, 18–31, 132

Kwik-print, 132

Labrot, Syl, 185
Liquid Light, 142–153
Litho film, 108–141, 193

Mackie lines, 3,4
Man Ray, 3, 4, 5, 33, 40, 167
Maskoid, 90, 105, 157, 164–65, 193
Magritte, Rene, 167
McPherson, Larry, viii, 186
Modern Art, Museum of, 97

Moholy-Nagy, Laszlo, 40, 41
Morgan, Barbara, 33
Morimoto, 153
Multiple printing, 58–69

Parker, Bart, 69
Polaroid, 48–57, 80–87
Photogenic drawing, 33
Photograms, 32–41, 44, 70–79, 132
Photomontage, 120–121, 131, 166–175
Polarizer, 22, 23
Posterization, 128

Ranalli, Dan, 44
Rantoul, Neal, 31
Rayogram, 33
Reticulation, 154–165
Riss, Murray, 47
Rejlander, O. G., 59
Robinson, H. P., 59, 67
Rockland Colloid Corp., 144

Sabattier, Armand, 3
Sabattier effect, viii, 2–17, 56, 132
Samaras, Lucas, 87
Siskind, Aaron, 71
Smith, Henry Holmes, 33, 74, 185, 186, 195
Smith, Luther, 29
Solarization, 3
Sommer, Frederick, 71
Surrealists, 167

Tanguy, Yves, 167
Teske, Edmund, 3
Toning, split, 42–47, 92, 96–107, 178–183
Tuckerman, Jane, 27

Uelsmann, Jerry, 3, 59, 68, 71

Walker, Todd, 3
White, Minor, 19
Widmer, Gwen, 95

X-rays, 132